LOVE

BRINGS

LOVE !

LOVE BRINGS LOVE
A homage to Alber Elbaz

RIZZOLI
NEW YORK

New York · Paris · London · Milan

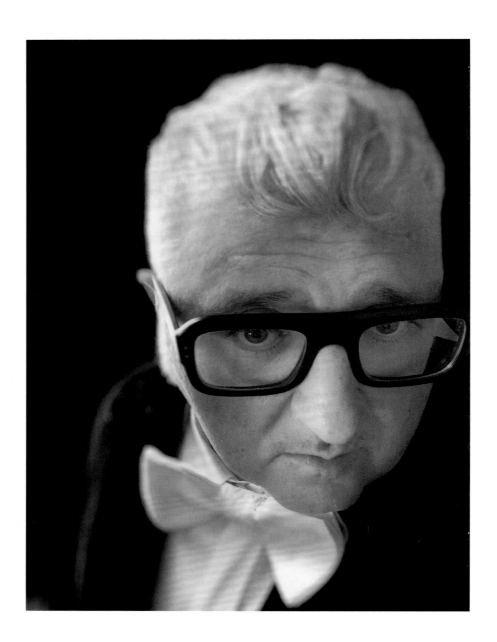

Alber Elbaz, 2019

Alber Elbaz

1961 — 2021

Alber Elbaz, was born in Casablanca, Morocco, and moved to Israel as a baby. He grew up in a very loving household with his mother, a painter: his father, a hair colorist: and his brother and two sisters.

At the age of seven, growing up in Holon, south of Tel Aviv, Alber began sketching dresses. He pictured strong women, from nurses, doctors, and policewomen to queens and elegant ladies in evening gowns. As a young adult, he went on to study fashion at the Shenkar College of Engineering and Design in Tel Aviv.

Upon graduation, he decided to take a leap of faith and move to New York. He packed a suitcase with 800 dollars from his mother and set off to discover the fashion world.

Alber's arrival in New York marked a change in his life. "When I dropped the 't' from my name, I found my way. In Judaism, if you change your name, you change your destiny."

In 1985, he worked briefly for a bridal firm before catching the eye of the iconic designer Geoffrey Beene. He stayed on for seven years as Head Designer. It was in New York in the early 1990s, that Alber met his partner and the love of his life: Alex Koo.

In 1996, Alber moved to Paris where he became the Design Director at Guy Laroche. After four spectacular shows that shot him to sudden stardom, he was offered the chance of a lifetime: succeeding Monsieur Yves Saint-Laurent as Creative Director of Rive Gauche at YSL.

At the turn of the millennium, YSL changed hands, and Alber moved on. Following a collection for Krizia he took the year off to travel throughout the Far East and India, gaining inspiration before returning to the spotlight.

In 2001, Alber started his fourteen-year tenure as Creative Director at Lanvin. There he earned critical acclaim and commercial success, cementing his worldwide reputation as a beloved designer. He revived "the sleeping beauty" transforming the historic house into a global brand. Renowned for dressing *all* women, no matter their age, size, or celebrity status, with a simple desire to "make women feel beautiful."

After leaving Lanvin, Alber traveled far and wide. He continued to create and design, collaborating with the likes of Converse Japan, LeSportsac, Frederic Malle and Tod's. He went back to school — not as a student, but as a teacher — running master classes in numerous fashion schools around the world. Enriched and inspired by the new generations he taught; he was ready to return to what he loved: Fashion.

In 2019, he announced AZ Factory in partnership with Richemont. AZ Factory was a new beginning, a new approach to fashion: both innovative and real. "Smart fashion that cares." Launching iconic and playful mini collections, he achieved what he always set out to be at the age of seven: a doctor. Perhaps not in the medical sense, but a doctor for the everyday needs of women throughout the world.

Alber's honors and recognitions are wide-reaching and significant. They include the International Award from the CFDA in 2005; the Chevalier of the Légion d'Honneur as well as *Time Magazines* 100 Most Influential People in the World distinctions in 2007; an honorary doctorate from the Royal College of Art in London in 2014; and he was made Officier of the Légion d'Honneur in 2016.

He left us too soon, on 24th April 2021, and will be greatly missed.

Words: Katy Reiss

LOVE BRINGS LOVE

AZ FACTORY 10
Alber Elbaz

ALAÏA 12
Pieter Mulier

ALEXANDER McQUEEN 14
Sarah Burton

BALENCIAGA 16
Demna

BALMAIN 20
Olivier Rousteing

BOTTEGA VENETA 22
Daniel Lee

BURBERRY 24
Riccardo Tisci

CASABLANCA 30
Charaf Tajer

CHLOÉ 32
Gabriela Hearst

CHRISTIAN DIOR COUTURE 34
Maria Grazia Chiuri

CHRISTOPHER 36
JOHN ROGERS
Christopher John Rogers

COMME DES GARÇONS 38
Rei Kawakubo

DRIES VAN NOTEN 42
Dries Van Noten

FENDI 44
Kim Jones

GIAMBATTISTA VALLI 46
Giambattista Valli

GIORGIO ARMANI 52
Giorgio Armani

GIVENCHY 54
Matthew M. Williams

GUCCI 56
Alessandro Michele

GUO PEI 58
Guo Pei

HERMÈS 62
Nadège Vanhée-Cybulski

IRIS VAN HERPEN & ADOBE 64
Iris Van Herpen

JEAN PAUL GAULTIER 66
Jean Paul Gaultier

THEBE MAGUGU 110
Thebe Magugu

THOM BROWNE 112
Thom Browne

TOMO KOIZUMI 114
Tomo Koizumi

VALENTINO 120
Pierpaolo Piccioli

VERSACE 122
Donatella Versace

LANVIN 70
Bruno Sialelli

LOEWE 72
Jonathan Anderson

LOUIS VUITTON 74
Nicolas Ghesquière

OFF-WHITE 80
Virgil Abloh

VETEMENTS 124
Guram Gvasalia

VIKTOR & ROLF 126
Viktor Horsting
& Rolf Snoeren

VIVIENNE WESTWOOD 128
Vivienne Westwood
& Andreas Kronthaler

RALPH LAUREN 88
Ralph Lauren

RICK OWENS 90
Rick Owens

ROSIE ASSOULIN 92
Rosie Assoulin

WALES BONNER 130
Grace Wales Bonner

Y/PROJECT 132
Glenn Martens

SACAI 98
Chitose Abe

AZ FACTORY 136
Alber's design team

SAINT LAURENT 100
Anthony Vaccarello

SCHIAPARELLI 102
Daniel Roseberry

SIMONE ROCHA 104
Simone Rocha

STELLA McCARTNEY 106
Stella McCartney

THE SHOW 144

ACKNOWLEGMENTS 197

CREDITS 199

LOVE BRINGS LOVE

Alber's mantra was always *Love Brings Love*.

He touched the heart of every person he met, regardless of status or age, with his generosity, sense of humor, and infinite empathy.

We all miss him every day and treasure our beautiful memories.

Alber was always intrigued by the story of the *Théâtre de la Mode*. That 1945 exhibition united sixty French couturiers as a beautiful expression of creativity, prestige, and solidarity.

Alber envisioned a new *Théâtre de la Mode* for today. His dream was to unite the best talents of the industry in celebration of love, beauty, and hope.

As a show, and as an exhibition, we are moved and humbled that the best creative minds have joined the AZ Factory team in paying tribute to his memory. The unveiling of these designs is a powerful expression of love and a beautiful celebration of Alber.

He would have been incredibly happy and honored to be accompanied by his esteemed peers and friends — his beloved fashion family — in realizing this dream.

His humanity and his laughter will live in our hearts forever.

Alex Koo
Alber's Partner

Laurent Malecaze
CEO, AZ Factory

BLK dresses.

Back.

ITALY

AZ Factory is me — AZ Factory is us. I want to elevate people and make their dreams come true. It's all about combining dreams and technology, beauty and meaning, fashion and function, emotion and smarts.

My challenge is to always be attentive and support women in this world. I want to create solutions for women and then to elevate it. I want to make solutions that project confidence, comfort, AND beauty. I had a dream to make a dress, just a simple dress, that can hug a woman. A dress that will hold you when you need it.

— Alber Elbaz

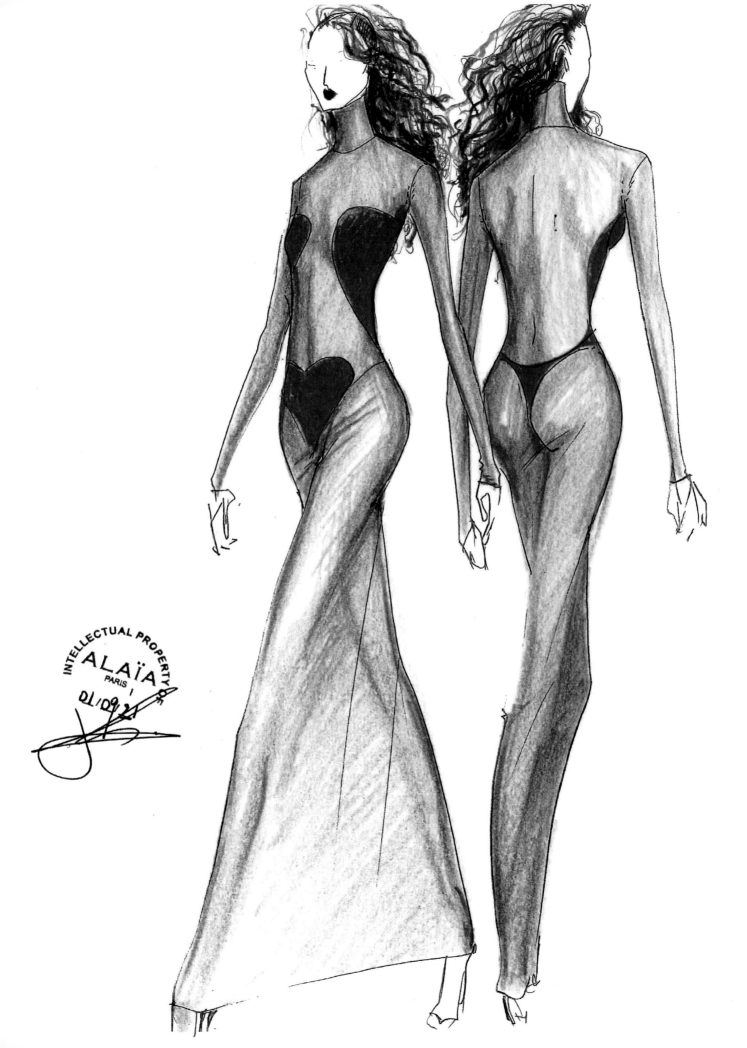

A dress as a message with all our love.
— Pieter Mulier and the Alaïa ateliers

A dress sculpted as a second skin to enhance the feminine silhouette. A heart magnified on the body to celebrate a shared and absolute love of women.

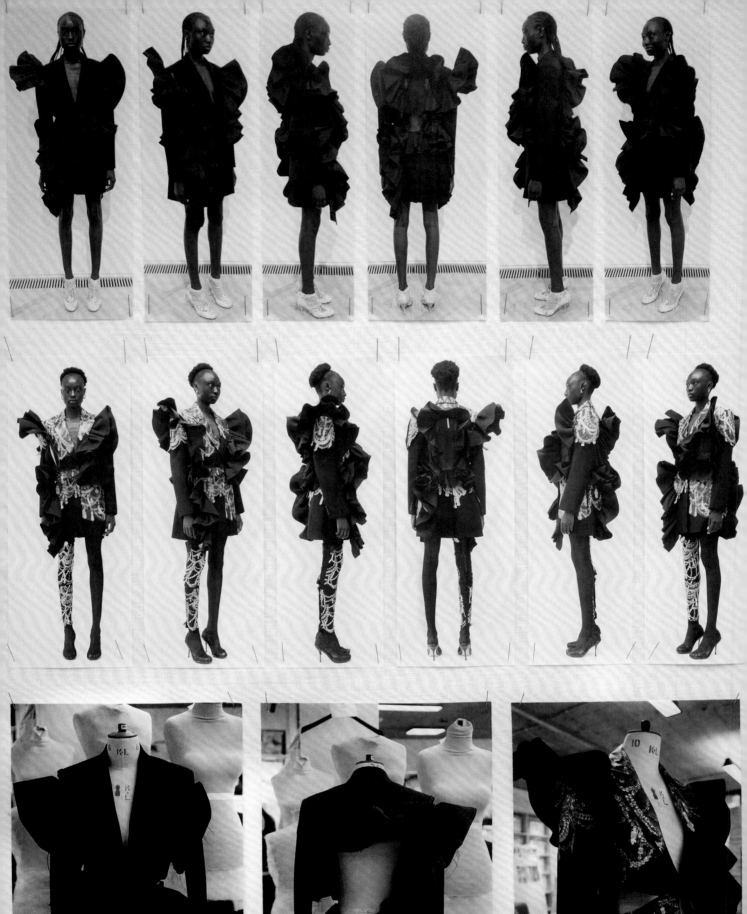

This dress is inspired by the love of creating clothes, a love that Alber and I always shared. We talked many times about the process of creation, about how, often, the toiles, early fittings stages and prototypes were more important to us even than the finished piece. What I loved about him is that he created his collections during fittings, by working close to the model, slashing and draping fabric directly on the body. He would always laugh about the fact that I sometimes forgot to take off my pincushion before coming out at the end of a show. He was a true creator and a huge inspiration to us all.

A single-breasted tailored tuxedo dress with cut-out sides and back, slashed shoulders, exploded ruffles and crystal embroidery and boots with crystal embroidery.

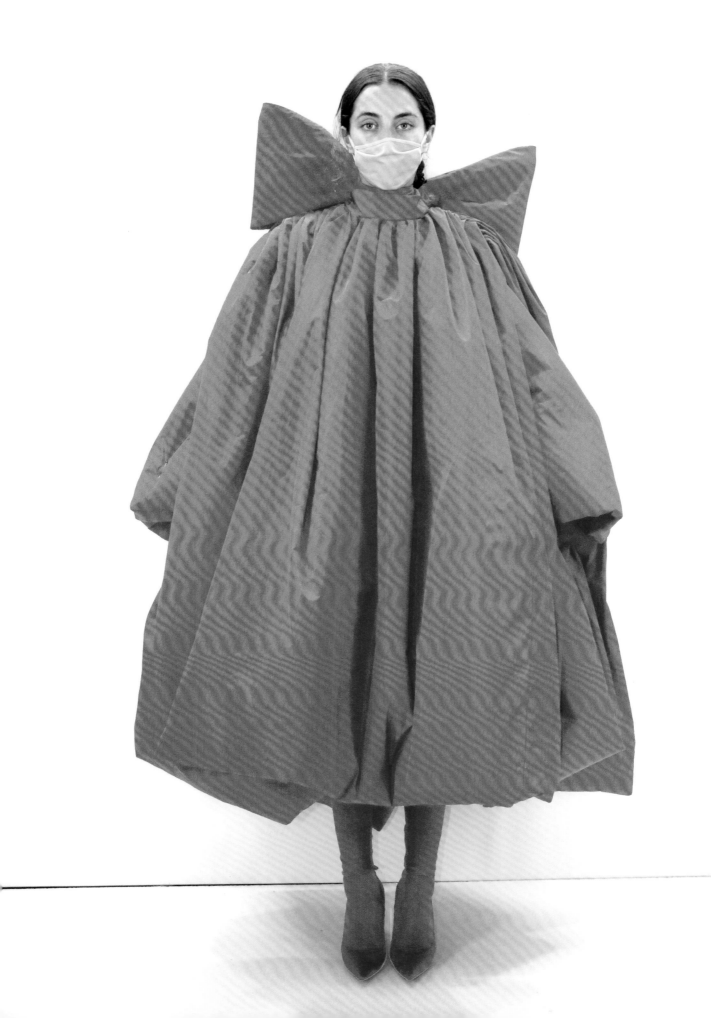

In tribute to the late Alber Elbaz, this Balenciaga nylon taffeta cape dress and pair of matching Balenciaga Pantashoes follows the cherished designer's principles of design, creating maximal volume using minimal seams, in one of his favorite colors, pink.

If you want to
pass emotion,

you have to
write a letter.

Emotions do not
pass in SMS
or in e-mail.

Inspired by the timeless magic of Alber's Fall 2013 Runway at Lanvin, this look merges the essence of his iconic show with a classic Balmain silhouette.

The dress in off-white silk satin combines a loose-fitting top with a draped miniskirt and sculptural long sleeves in fuchsia silk organza ruffled flowers with embedded crystals, all in honor of his mastery of fabric manipulation. Olivier's reinterpretation of Alber's self-portrait embellished with appliqué tulle, pearls, and crystals commemorate Alber's signature illustrated t-shirts.

Custom-made gold stiletto sandals in fuchsia satin embellished with ruffles mirror those on the sleeves.

An emerald green necklace and bracelets in mixed materials with jeweled crystal brooches honor the accessories of this same collection, echoing Alber's eternal reminder of always embracing LOVE.

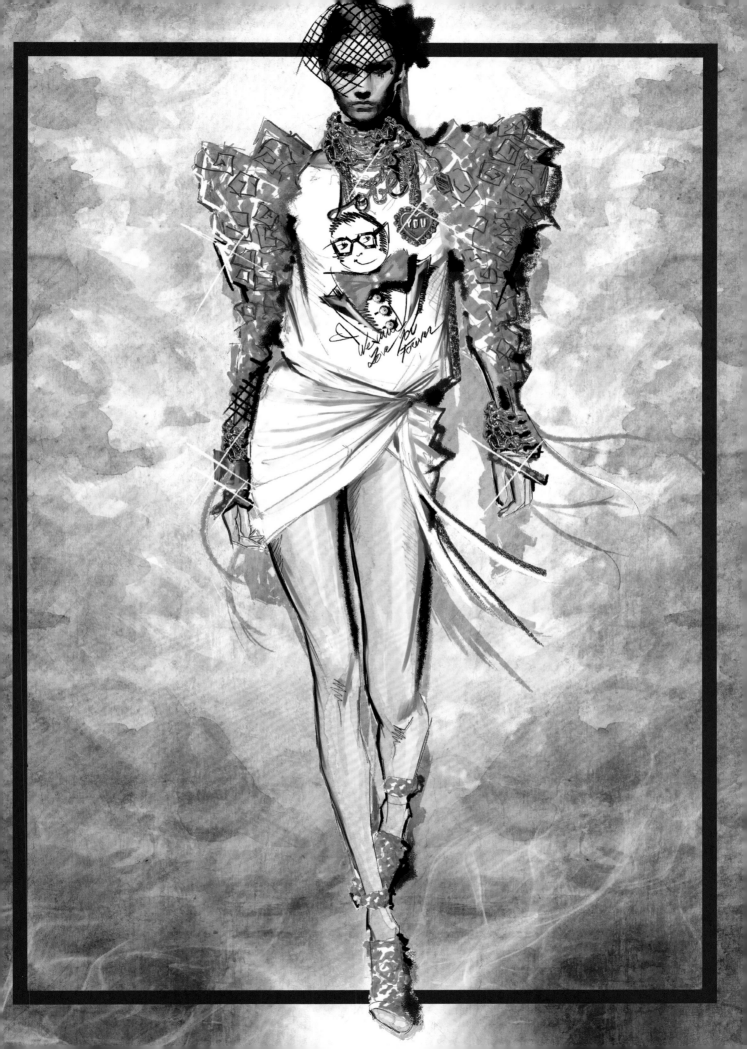

This illustration draws inspiration from the playfulness and joy that Alber Elbaz cherished during his career. The pearls are in a parakeet green — a recurrent color throughout Alber's work and a favourite of Daniel.

Thank you Alber for your inspiration and magic.

Beige silk satin asymmetric gown with polished ring detail, metallic exaggerated chain-link necklace and bracelet, metallic patent leather sandals.

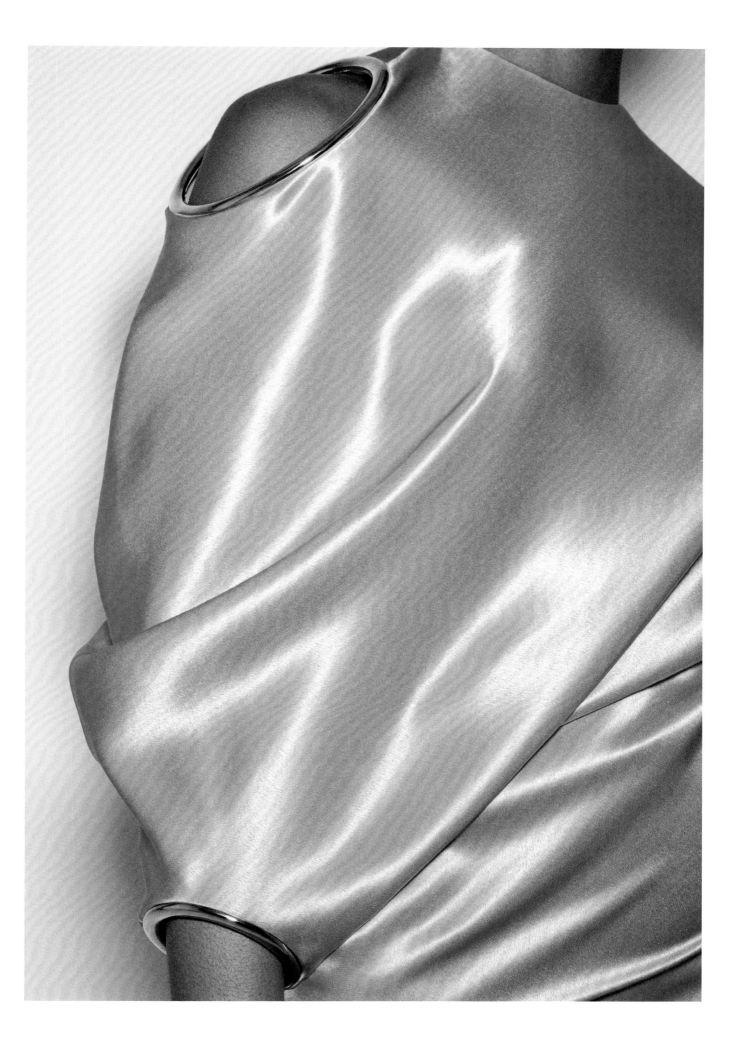

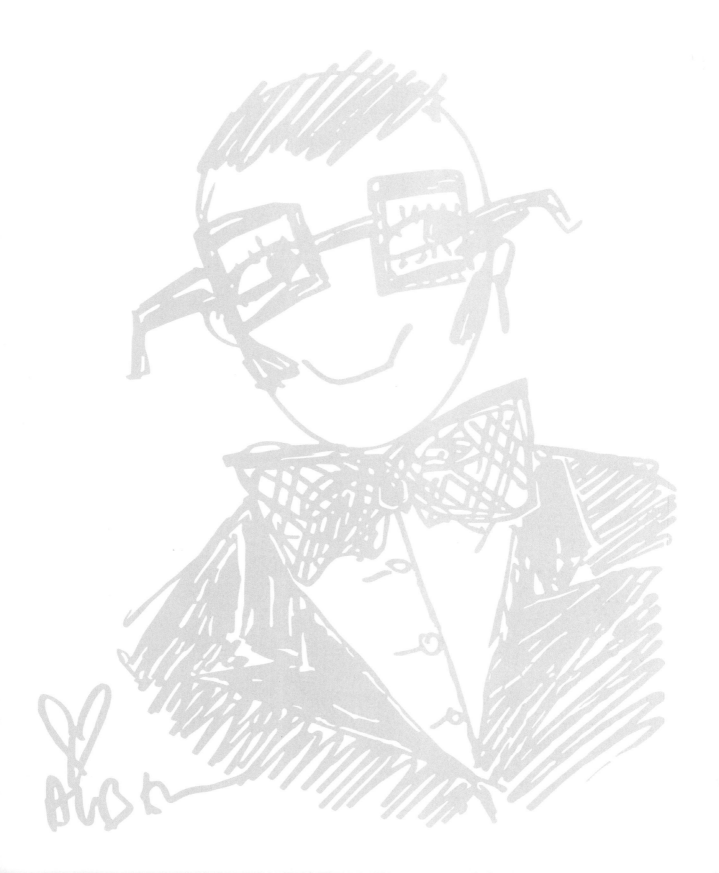

When nothing goes right,

go left.

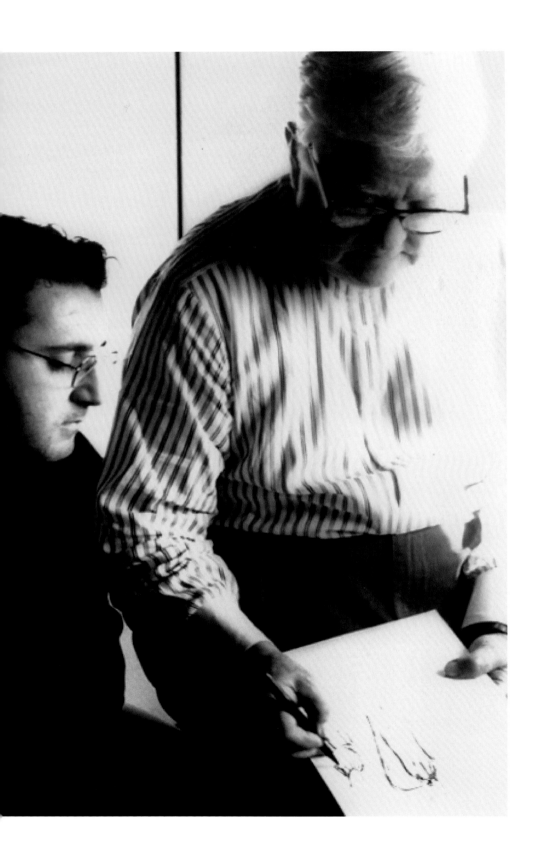

Alber Elbaz with Geoffrey Beene, 1989.

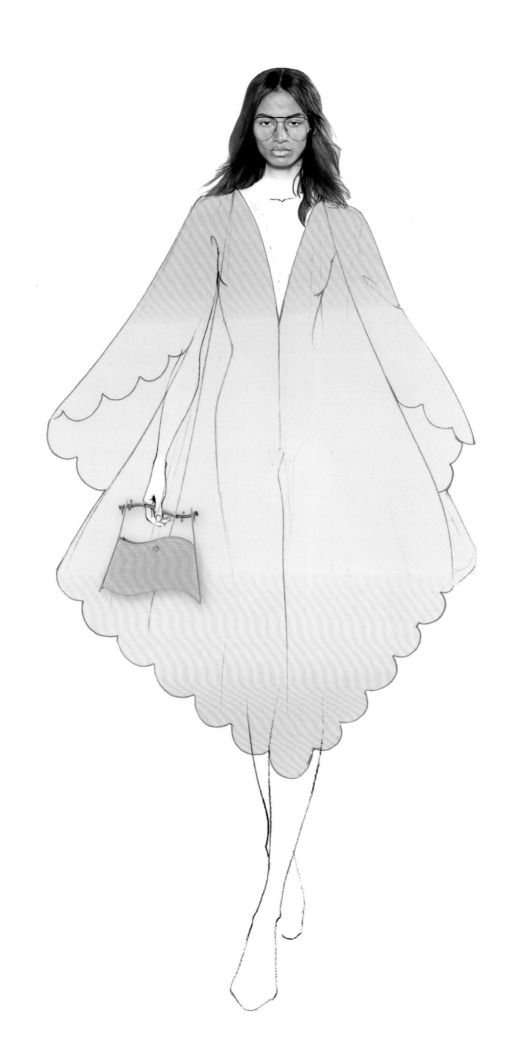

Alber Elbaz is one of the few designers who has always inspired me a lot. His optimism and his *joie de vivre*, which were reflected in both his work and his personality, are — among so many other things — what made me want to be part of this project.

Designed in homage to the visionary designer Alber Elbaz, Casablanca has created a chiffon dress in a pastel ombré which effortlessly drapes over the female body. Intended to be a celebration of Alber's signature *joie de vivre* and life-long passion for all women, to feel happy and confident.

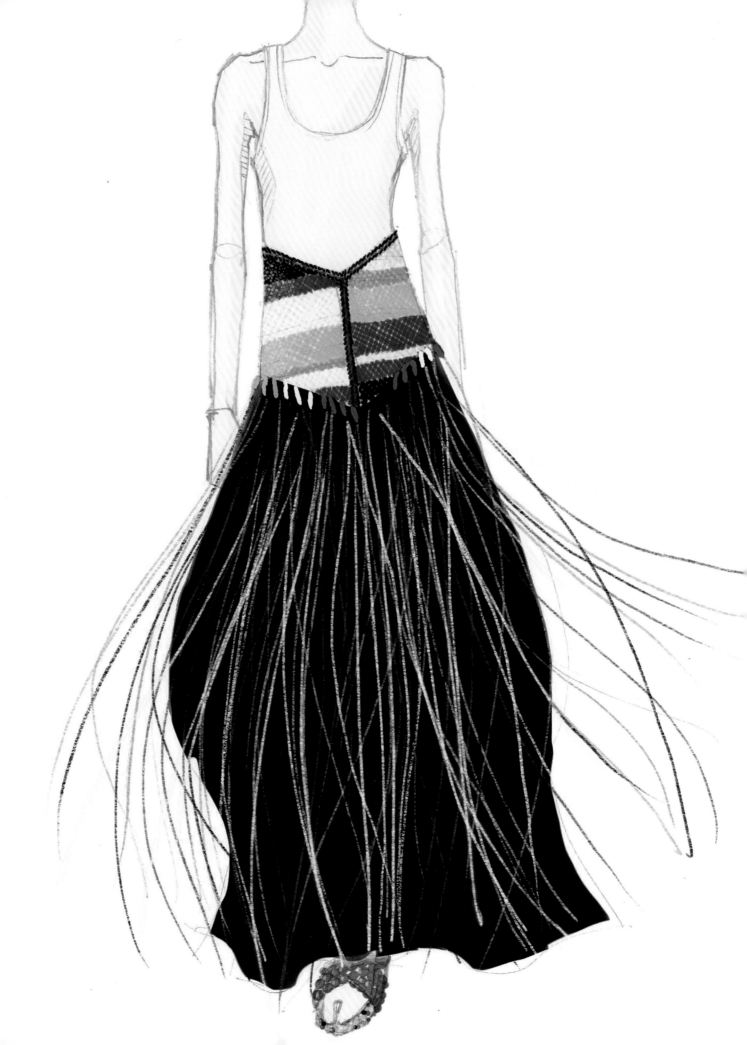

I wanted to pay tribute to the festive and elegant French chicness that Alber was so good at.

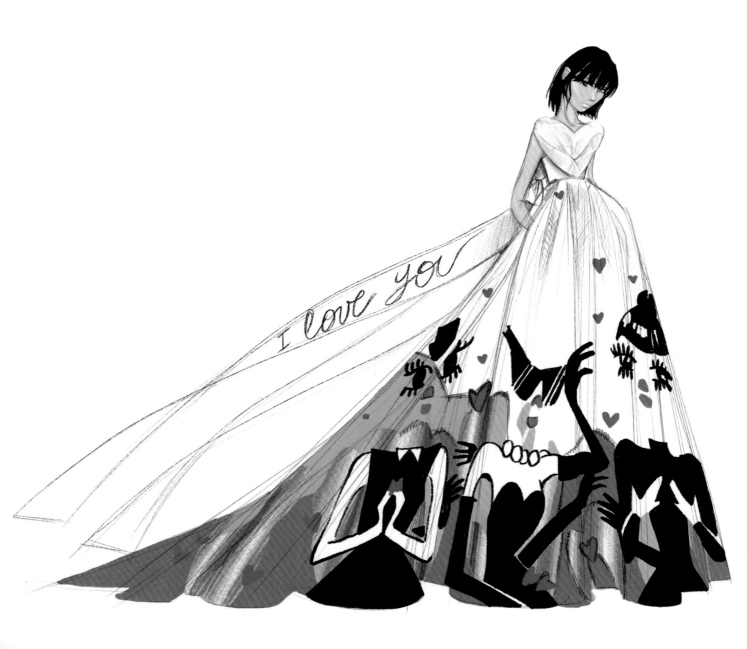

When Pierpaolo Piccioli and I were first appointed Creative Directors at Valentino, *Vogue Italy* organized an official dinner to which we were invited for the first time as Creative Directors. I felt very uncomfortable being surrounded by so many established designers and attending an official event for the first time. Alber was the first to approach me and make me feel welcome and at ease. He congratulated me and stood by me throughout the event. His generosity and empathy really touched me. He became like a brother to me, someone who always enlightened me with his experience, wisdom, and love.

Bustier evening dress in tulle and tarlatane with hand-embroidered and hand-painted silk satin appliqué patterns paying homage to Alber Elbaz and his work as a couturier.

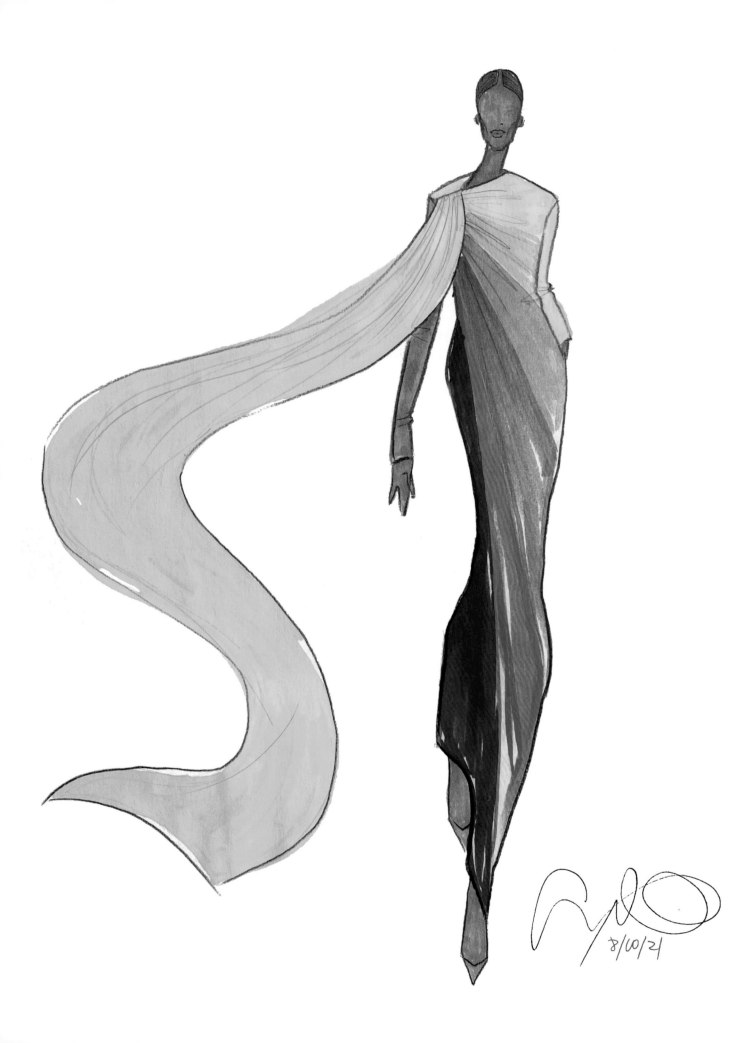

Unfortunately, I never got the chance to meet Alber in person, but his energy and enthusiasm for his work and the women he dressed will stay with me forever. My first experience with his work was his Spring 2007 show for Lanvin — I was in 7th grade. I remember eagerly browsing through Style.com and being enamored by his skill, clarity of voice, and obvious love for beauty. He still remains one of my fashion fathers 'til this day.

I was inspired by Alber's smile, the insouciance and vitality of his sketches, and his balance of precision and serendipity in his work. We've created a silky gown with a trailing streamer in rainbow patchworked silk charmeuse.

The human brain always
looks for harmony and logic.
When harmony is denied,
where there is no logic,
when there is dissonance...
a powerful moment is created
which leads you to feel an
inner turmoil and a tension...
that can lead to find positive
change and progress.

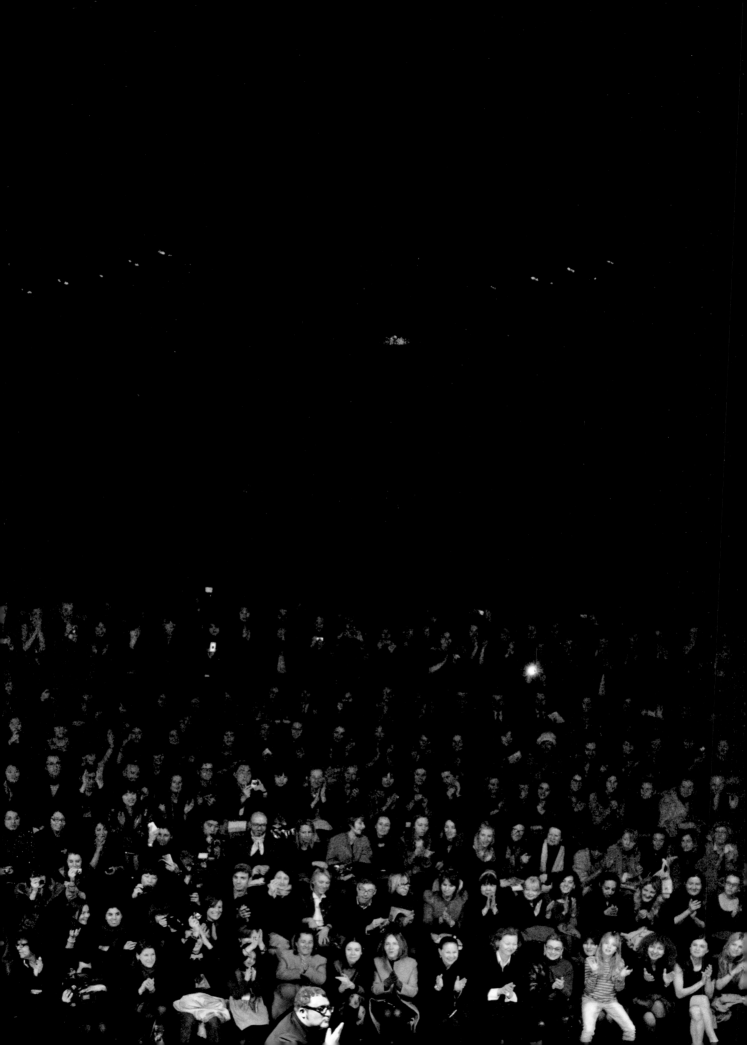

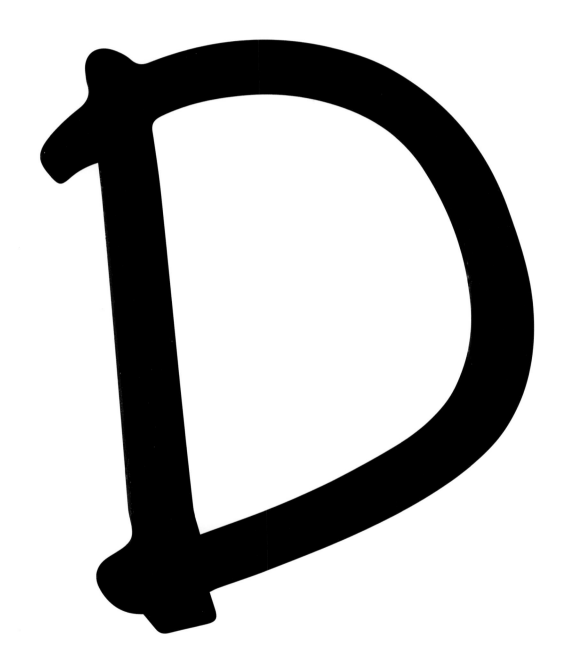

Your playful joy, talent, and great craft forever stood behind every garment you created. It is only fitting to us that we have you step forward on ours in tribute to you.

Long asymmetrical coat with draped sleeve.

Photographic jacquard of an Alber Elbaz sketch developed with Tessilclub (long-time collaborators of Alber).

Headpiece by Stephen Jones: Alber classic bow with satin ribbon wig and glasses on the back of the head.

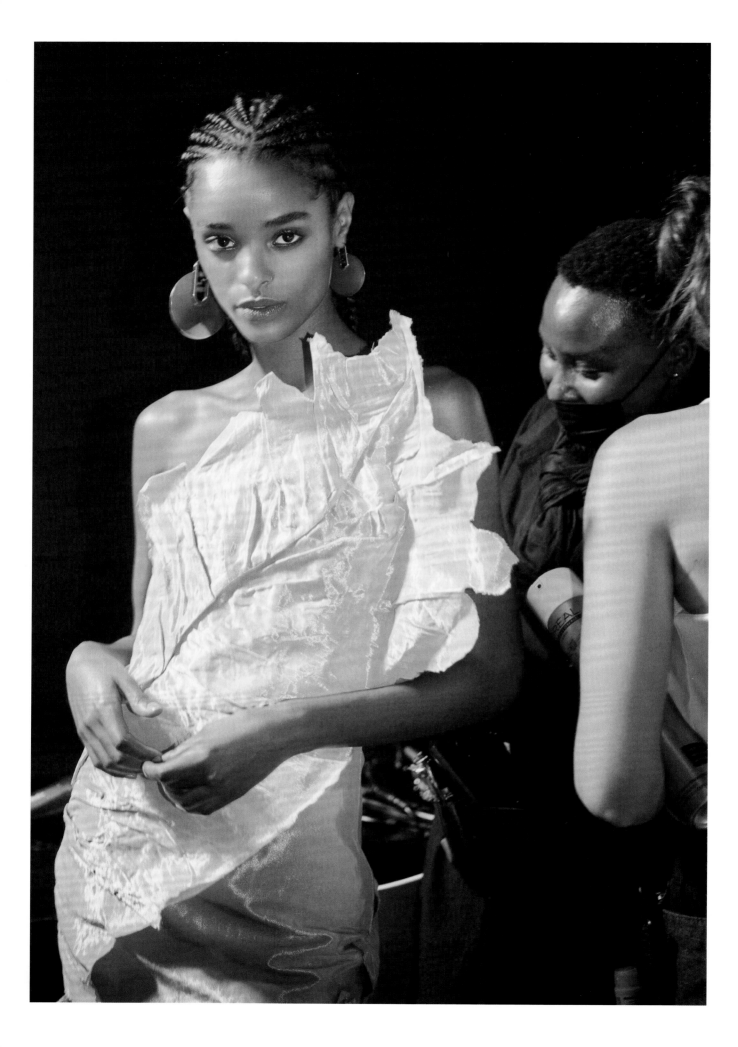

Unfortunately, I did not get to meet Alber that much but, when I did, he was always extremely generous. I remember one time going to Japan and he was sitting in the seat I normally sit in on the plane. He came on board and said, 'I heard you wanted to have my seat — would you like to sit next to me?' We then chatted the whole way to Japan and he was nothing but gracious and kind.

I was looking at the exuberance of Antonio Lopez's work and elements reminded me of Alber's beauty and his fashion — specifically his sense of humor and tongue-in-cheek irreverence. I wanted it to be humorous, like Alber himself.

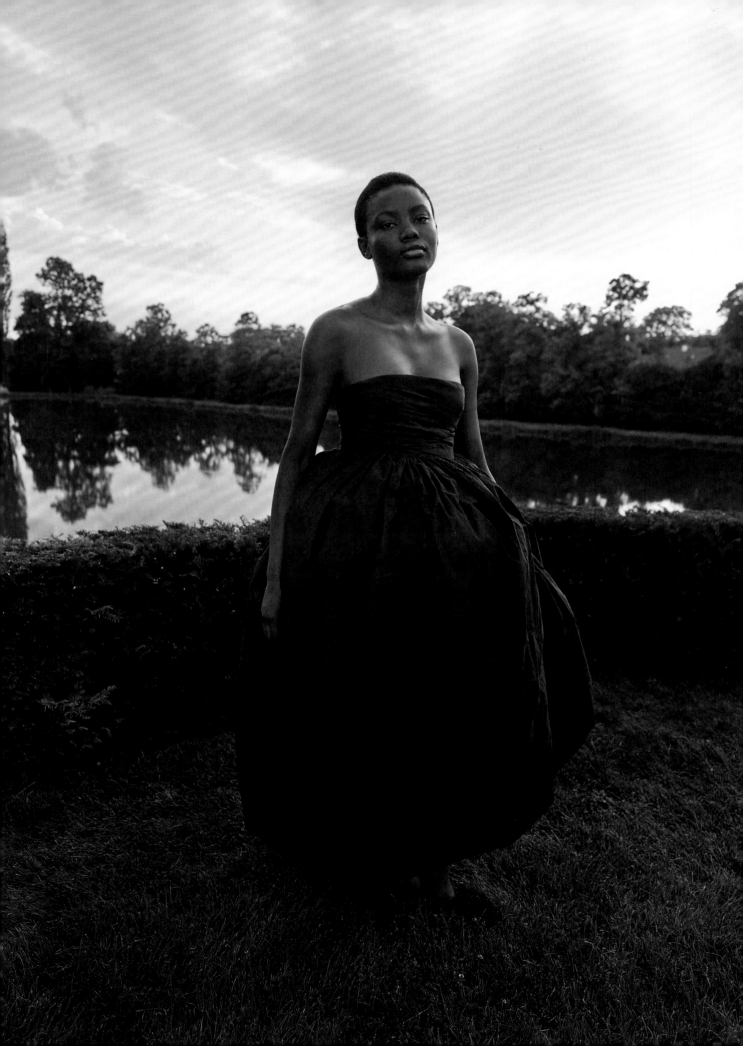

Dearest Alber. Your warm thoughts and beautiful flowers I received before every single one of my shows were truly faithful to your caring soul, which will live on forever; you were and will always be my lucky charm.

Born out of the encounter between the Giambattista Valli ateliers and the AZ Factory philosophy of beautiful and purposeful fashion, Mr. Giambattista Valli created an Haute Couture — inspired silhouette from a woven technical fabric traditionally used in activewear, the little black "Ballon" dress.

Sometimes you don't
really need armor
to feel protected.

Sometimes maybe
you just need
a chiffon dress
to hug you.

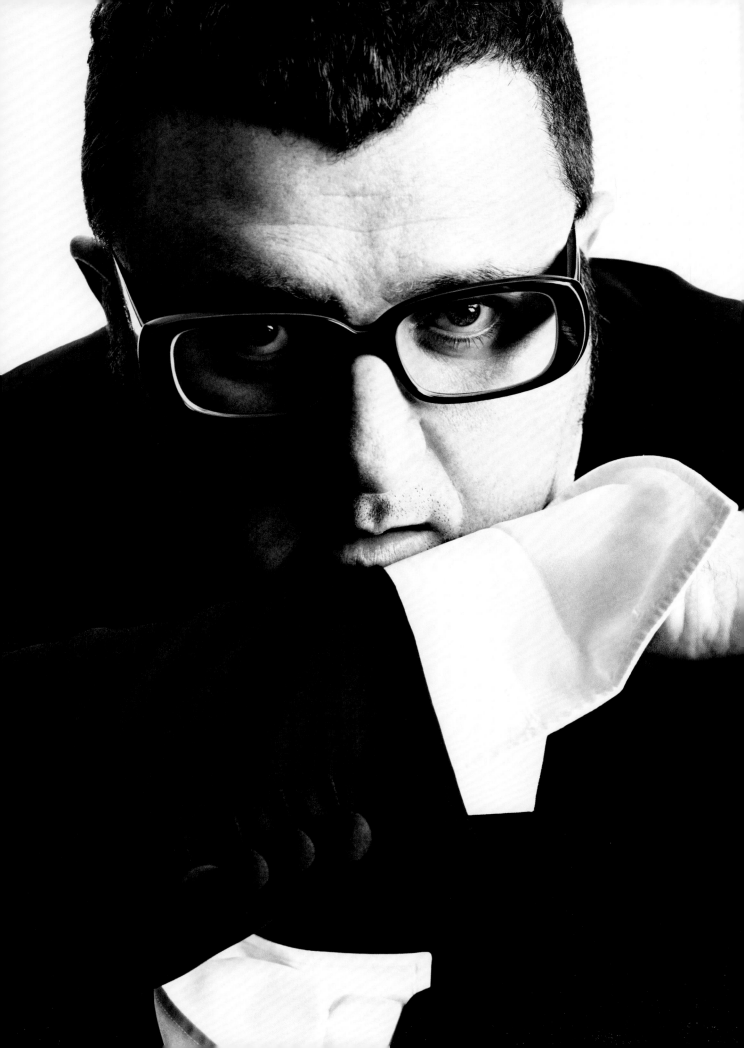

Fashion should be simple.

Life is already complicated enough.

I have always been drawn to the light-hearted and ironic side of Alber Elbaz's personality, the joyful touches he brought to glamour, the style he envisioned with ease in mind. I've always felt that he treasured freedom: the freedom to create designs in varying sizes from XXS to XXXXL, as with his latest project AZ Factory, the freedom for women to decide what they please — a combination of pragmatism and elegance. These are good-natured thoughts. And it is precisely these kind thoughts and generous spirit — which I find reflected in this tribute fashion show project — that instantly won me over, because they capture Alber Elbaz's character ever so precisely. He had a very special talent and that should be how we remember him.

This bustier dress embodies an expressive, delicate, transformative character, underscored by a lightweight luminosity. The long, flared skirt creates the impression of a giant inverted floral trumpet, fluid and weightless. The decorative trim at the hem and throughout the garment weaves a sinuous path that recalls the natural world, just as the color jade calls to mind an enchanted garden.

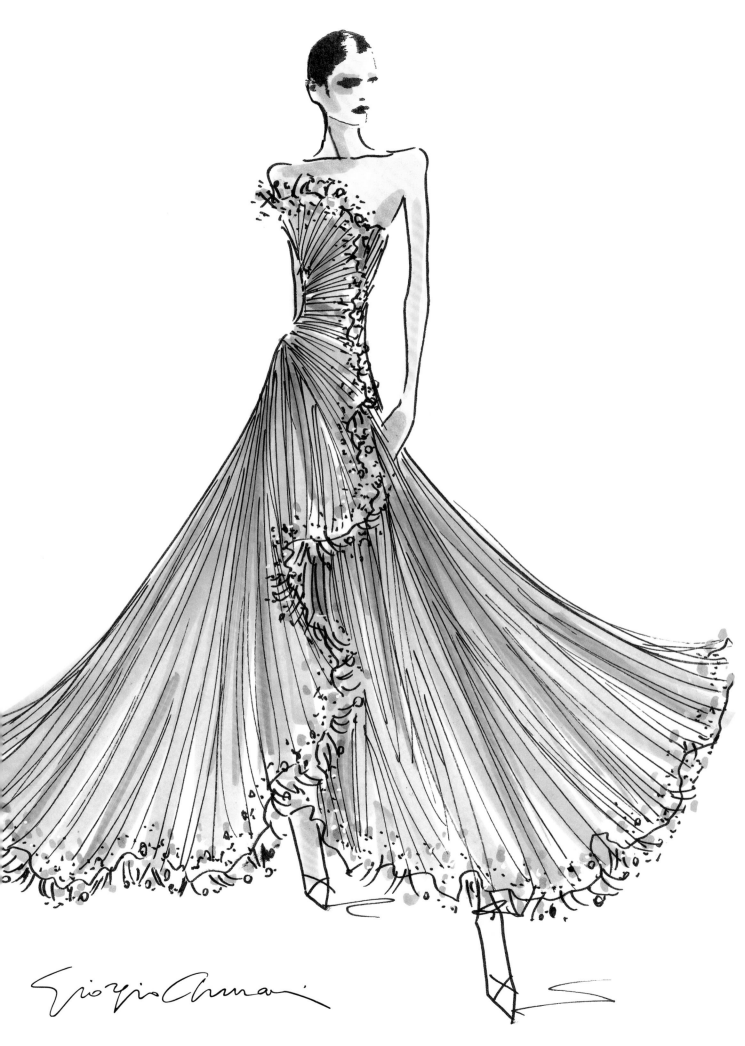

I've always really admired Alber Elbaz for his talent, his humor and his benevolent eye.

For this show, I wanted to create a dress inspired by one of his iconic designs, cross-pollinated with my own language for Givenchy. We chose black raffia and lurex for an asymmetrical dress with a bodice in green duchess satin and straps made of pearls enveloped in green chiffon as a nod to one of his emblematic contributions to fashion. In the spirit of hybridization, we added Givenchy's heritage 4G in the form of a chain and plumetis stockings, as well as the new Monumental Mallow shoes in shiny black, which I think Alber might have appreciated for their humor as well as their comfort.

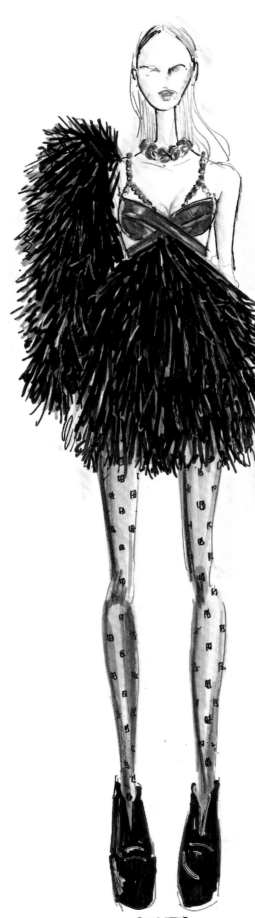

Matthew
4
Alber ♡

Gown with hearts décolleté in electric purple crystal grid embroidery on duchess base with side slit. Jacket in electric purple crystal grid embroidery on duchess base, fabric feather trimmings and cuffs. Black gloves feature same embroidery technique.

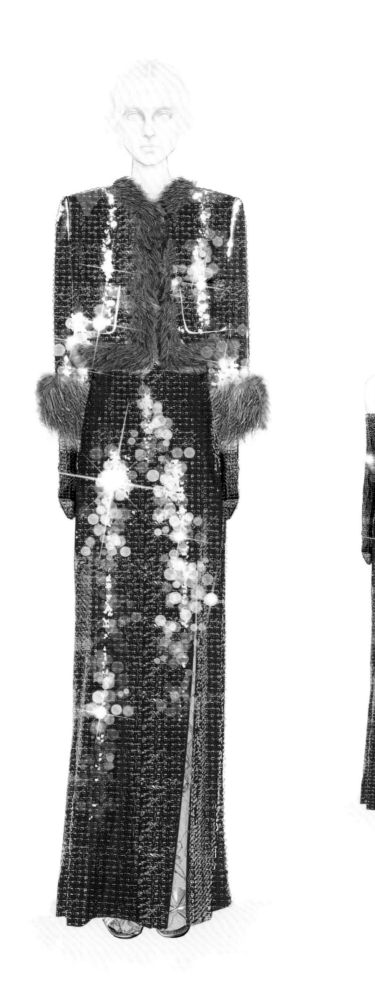

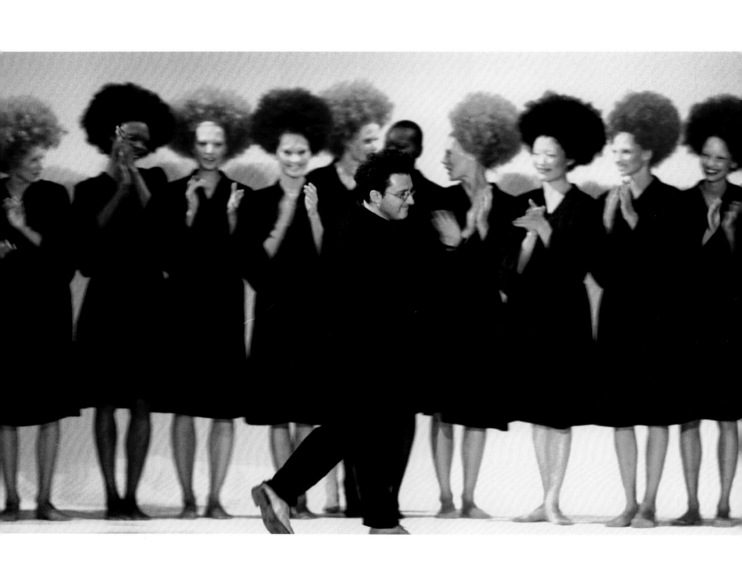

Alber Elbaz for Guy Laroche, 1998

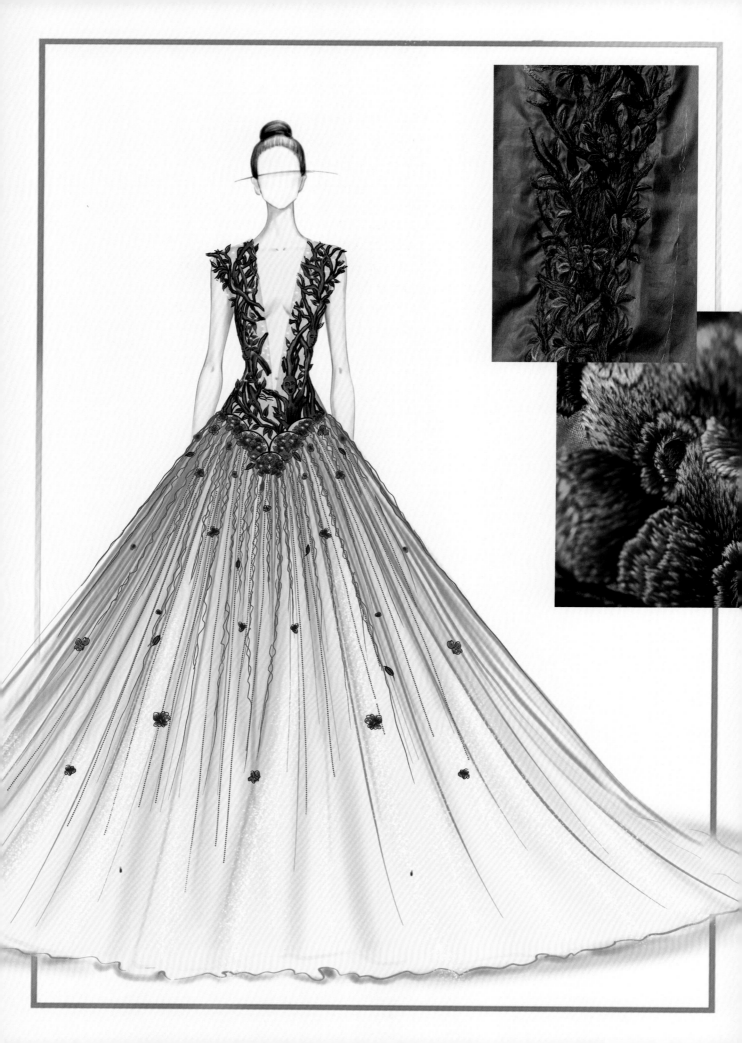

I met Alber for the first time in Paris. He was very passionate and had a good sense of humor. We coincided on many design ideas and concepts — he enjoyed warm, emotionally infused creations, and we shared the same thoughts in this regard. Alber loved China and visited my studio when he was in Beijing. I was so excited to share with him all my creations, including some garments with the finest craftsmanship and artistry. He never hesitated to express his appreciation for me and my work, which made me feel very humbled and was incredibly heart-warming. He was curious about every new inspiration: I once told him that I had made a signature embroidery with my name on it using my hair. He was deeply interested in the idea and remembered it fondly. Every time he saw me again in Paris, he would joke that he liked my hair. The last time I saw Alber, what most impressed me was his desire and expectation of his work and projects — to pass on the spirit of haute couture to the world. It is a sentiment he always expressed to me. I believe that he was a man full of energy and love, and a creative genius who could brilliantly combine feminine beauty with today's style.

The hero of fashion is gone, but his soul and spirit of couture will live on forever. I created a couture dress with flowers and trees to honor my friend, Alber Elbaz. His life in fashion and couture is like a forest or a tree in the earth, taking deep roots and growing thickly, bringing the world indispensable spiritual and creative treasures. The artistry and vision that Alber brought to the fashion industry will never be forgotten, and his works will be an unforgettable part of fashion history.

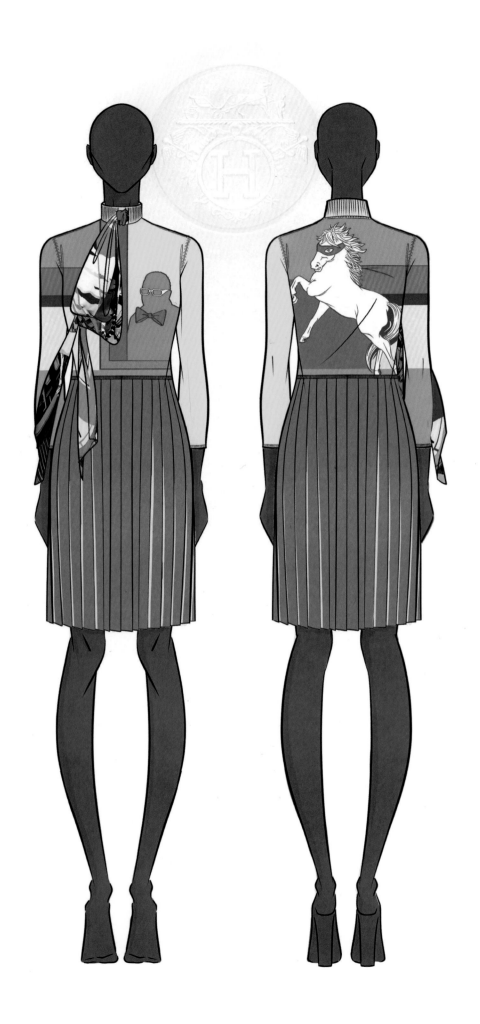

I wanted to design a silhouette that would be an homage to Alber Elbaz, his creativity and playfulness.

To make a dress like this one, that blends silk and leather, takes different sets of know-how. I took inspiration from the *Minuit au Faubourg* scarf designed in 2014 by French artist Dimitri Rybaltchenko, in which we get a glimpse of that most cheerful of neighbours, Alber.

Cartoon-like on the scarf, Super H, a super hero horse is poised to leap from the roof-top garden on the Faubourg Saint-Honoré before galloping over the Paris rooftops. Alber's figure is visible in one of the windows across the street from the Hermès flagship store.

A dress in two different fabrics, with a *Minuit au Faubourg* silk jacquard knit top, and a pleated skirt in chestnut brown lambskin, 'remeshed' to a *Minuit au Faubourg* silk knit, with slit collar threaded with an orange *Minuit au Faubourg* scarf 70 cm in silk twill.

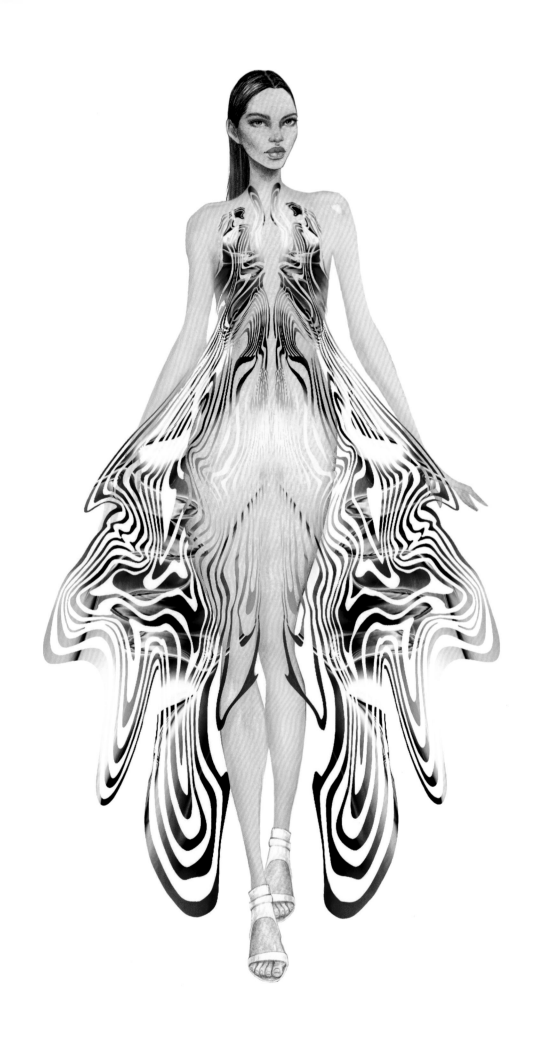

Alber and I loved talking about the future. When I think back on our past conversations, I see the sparks in his eyes when we spoke and laughed about this vast open space of possibilities. In our last conversation he passionately asked me 'if science could save fashion.' In these vivid conversations, he was always transcending his dreams. It is this mindset I will cherish, reminding myself to keep questioning.

Celebrating female empowerment, Alber Elbaz is known for his lighthearted, contemporary designs that blend traditional dressmaking and modern silhouettes seamlessly into one another. For her contribution to this show hosted by AZ Factory as an homage to his work, Iris Van Herpen plays tribute to his legacy by creating a look which showcases the creativity of a women-led atelier that keeps pushing the boundaries of craftsmanship and innovation within fashion and design. In memory of his bold explorations of colour and un-usual interpretations of what is traditionally considered "elegant," Van Herpen draws inspiration from Suminagashi patterns of the ancient Japanese art of "floating ink on water" technique and develops an original pattern gradient-dyed in a vibrant palette of warm shades of red, purple and orange mixed with white and black. Including development, print- and patternmaking, laser-cutting then hand-stitching the dress panels, the dress takes around six months to make. The vivid line and print work moves gracefully around the body, culminating in a future-facing silhouette that challenges traditional notions of the handmade and is exquisitely feminine at the same time. Iris Van Herpen collaborated with Adobe to create this custom dress, helping Iris bring to life her own unique style and voice that speaks to how creativity and Adobe are helping shape the fashion industry. By using Adobe Photoshop and Adobe Illustrator to create her own designs, the maison is translating the old craft of Suminagashi, which dates back to the 12th century, into a modern reinterpretation of itself in order to create a unique look, which is true to Alber Elbaz's visionary spirit as well as Iris Van Herpen's universe and DNA.

Une robe coeur s'est imposée tant Alber en avait et qu'il a mis dans toutes ses créations et ses collections.

A heart dress was evident as Alber had such a heart that he committed to each of his creations and collections.

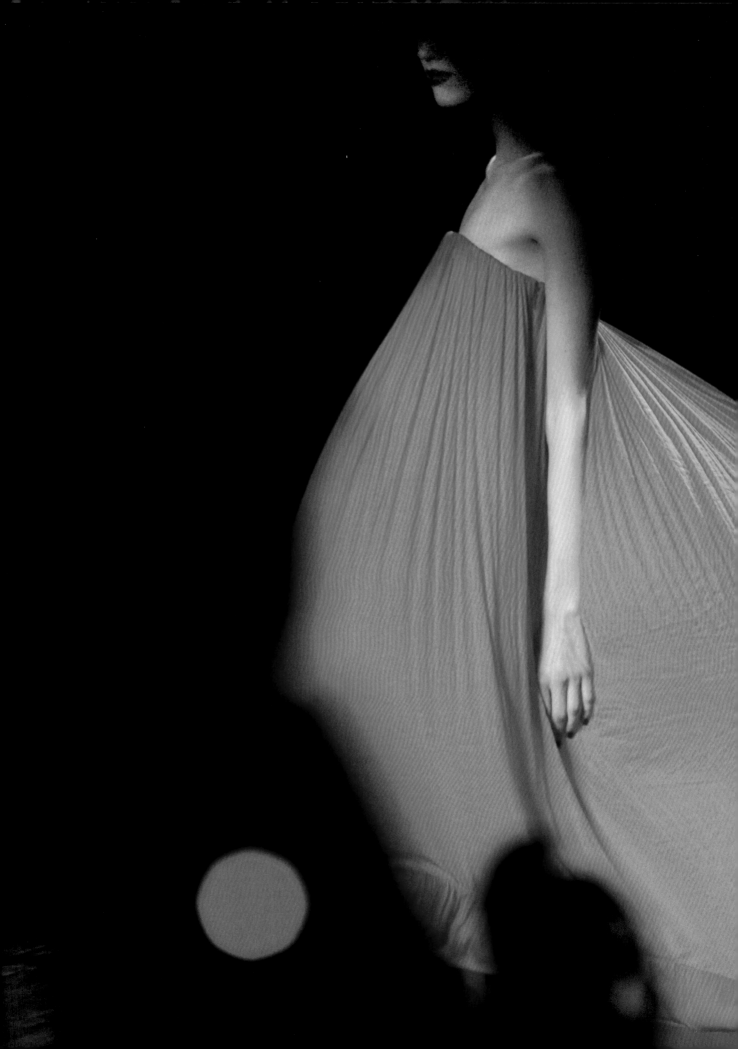

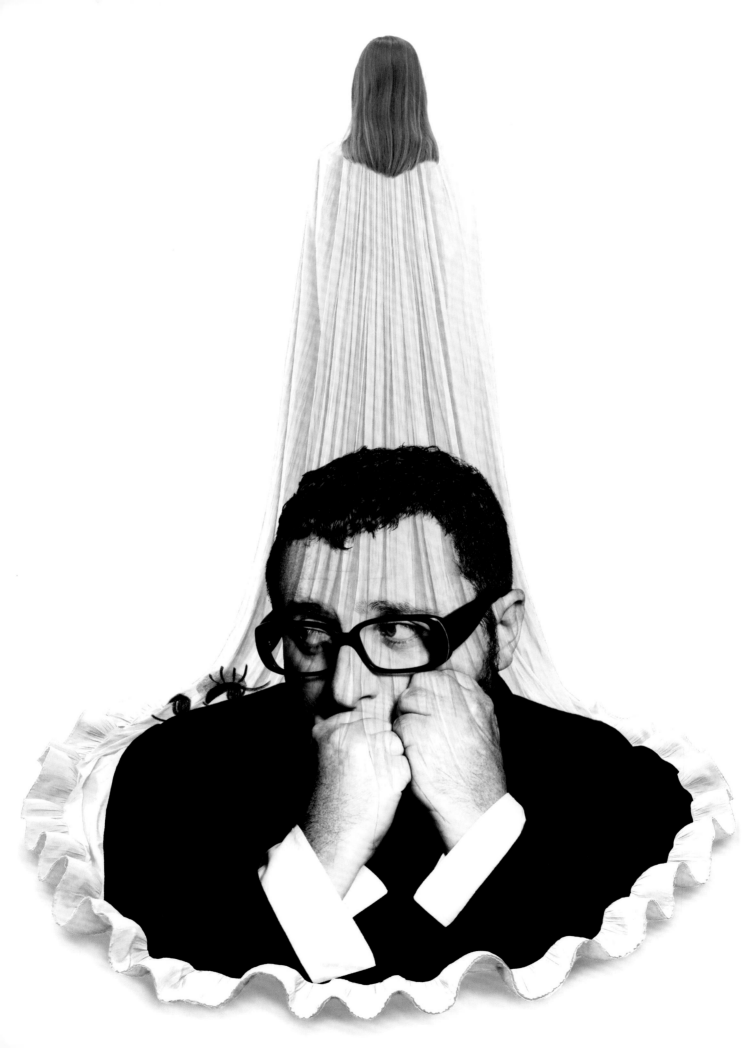

LANVIN
PARIS

I arrived in Paris in 2008 to study Fashion
The summer 2008 Lanvin collection was everywhere
and i was litterally struck by it.
Canary yellow, emerald green and coquelicot red
were the colors of these 3 magnificent dresses,
blown like sailing boats and bringing the
most fabulous women from the runway to an
ethereal destination.
This marked me forever and these 3 dresses
were the first archives i asked to see in
real when i first arrived at Lanvin in 2019.
When i was asked to participate in this
tribute to Alber Elbaz it came to me
naturally to channel this memory.

Love brings Love

Bruno

JEANNE LANVIN S.A. capital 16 297 330 euros RCS Paris 612 048 629
Siège social 15 rue du Faubourg Saint-Honoré 75008 Paris T. +33 1 44 71 33 33 F. +33 1 44 71 33 91

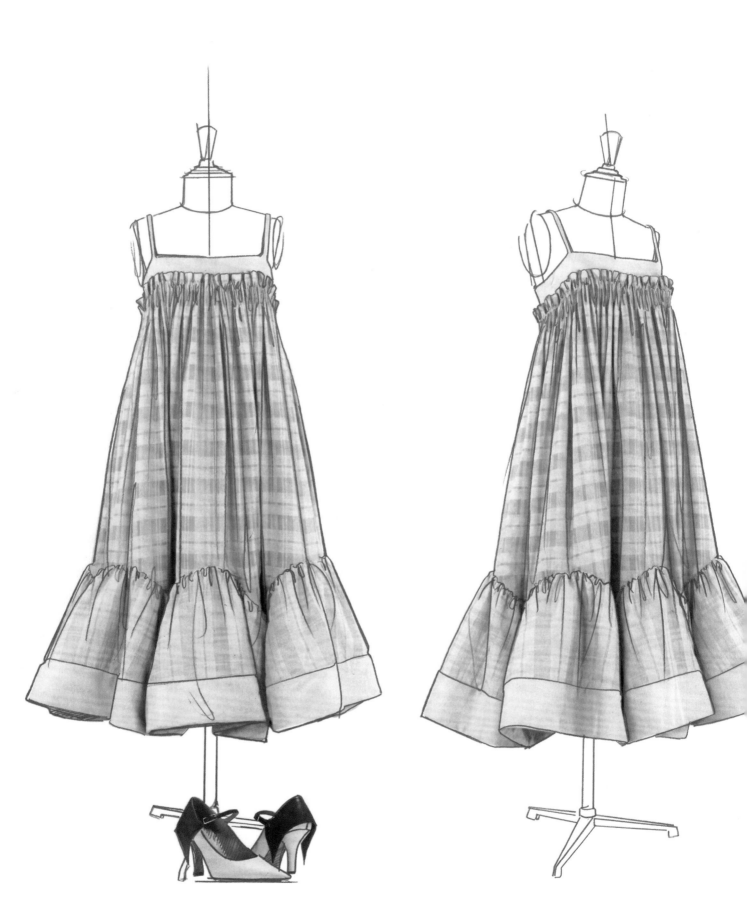

Crafted in a silk-cotton jacquard check with an oversized flounce detail, this dress pays homage to the joy and femininity for which Alber Elbaz was best known. Drawing inspiration from his signature juxtaposition of ready-to-wear and haute couture, we created a playful trapeze silhouette where textile and construction combine to celebrate both casualness and couture savoir-faire.

"Shocking Pink" bubble shape dress in satin leather with a black embroidered collar chain. This dress is inspired by Alber and Nicolas's works on volumes and shapes while the pink is a direct nod to Alber's most iconic color.

Alber Elbaz, 2021

I've always said fashion is like roast chicken:

you don't have to taste it to know it is delicious.

DANCE
Smile
kiss
DREAM

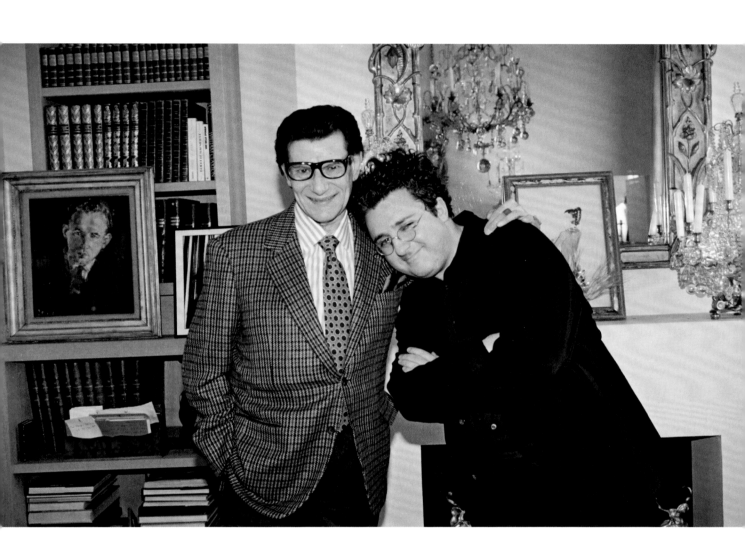

Yves Saint Laurent and Alber Elbaz, 1999

"HOMAGE TO ALBER"

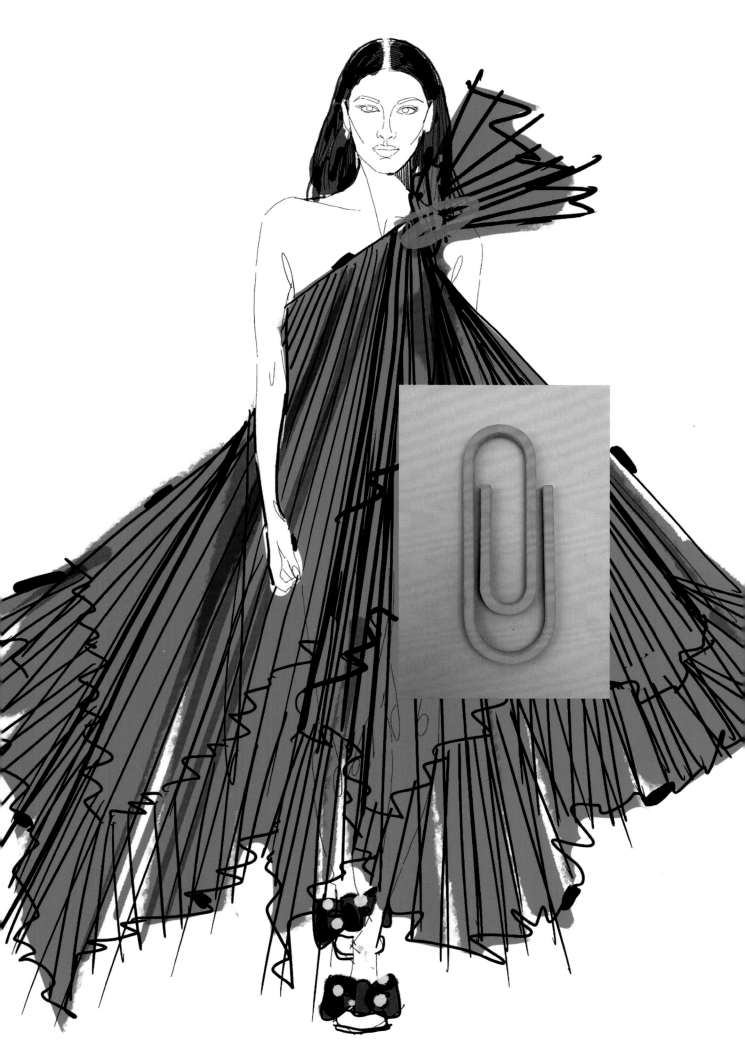

To pay homage to Alber Elbaz, we created this black velvet dress referring back to our SS21 collection, with a press button closure on the side opening up into a knee-/ thigh-high split. The finishing touch is a necklace-like neckline, but make it punk — with pins showing pictures of Alber and some of his quotes which have inspired us all.

When
I know,

I think.

And when
I don't know,

I dream.

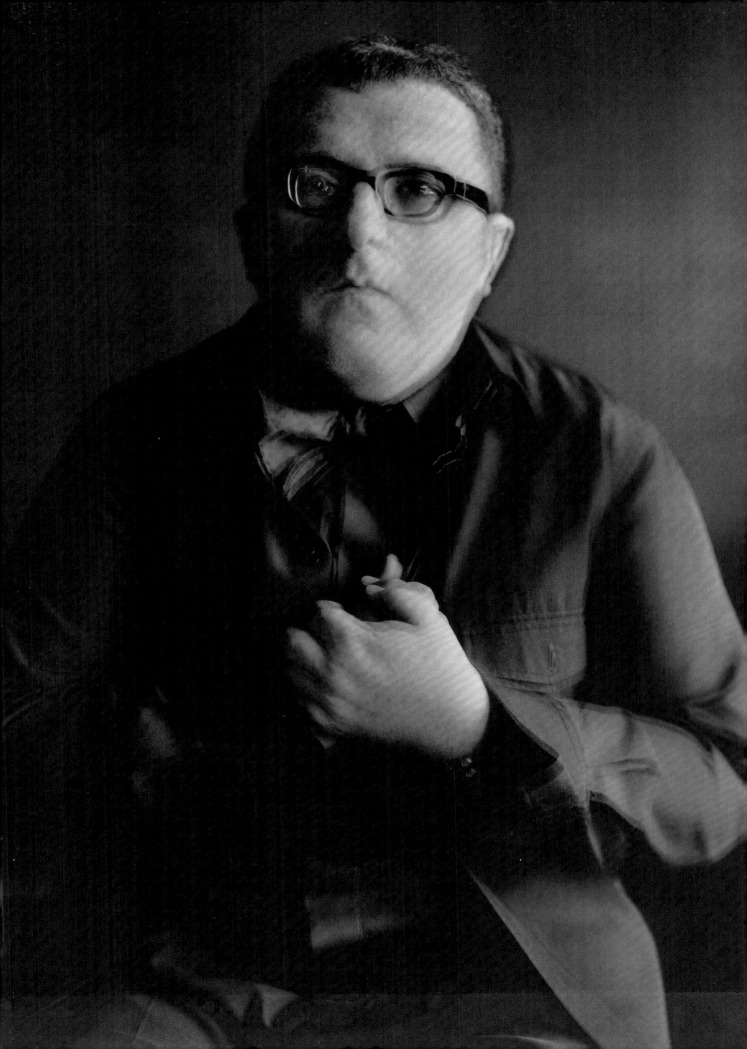

My mother once asked
her friend to tell her about
accounting and she said:

"It's easy!
You get and you give,
you give and you get."

For me this is the
essence of life:

We have to give and
in return we get, and
when we get, we give.

It has to be both ways.

Alber was larger than life, but in a humble way. Whenever we met, I was touched by his warmth and his special joy for living. He always said he preferred to whisper than be loud and his designs reflected that quiet beauty. He brought a genuine integrity to his craft and the way he lived.

Ralph Lauren iconic cashmere Polo Bear sweater worn with black wool suiting trousers, a white cotton broadcloth shirt, a red silk faille bow and black brogues.

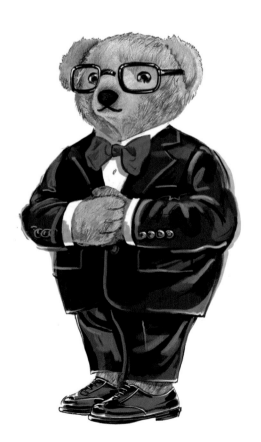

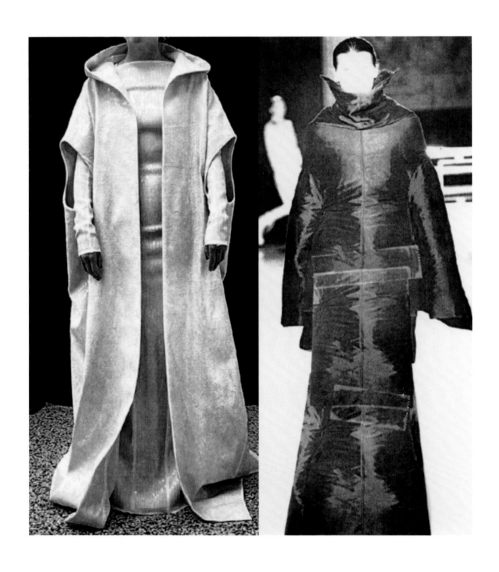

Alber always had such a light touch with washed silk gazar in beautiful colors – executing some of my space-filling shapes in washed pink gazar felt like the most suitable tribute to someone who always made me feel so good to be with.

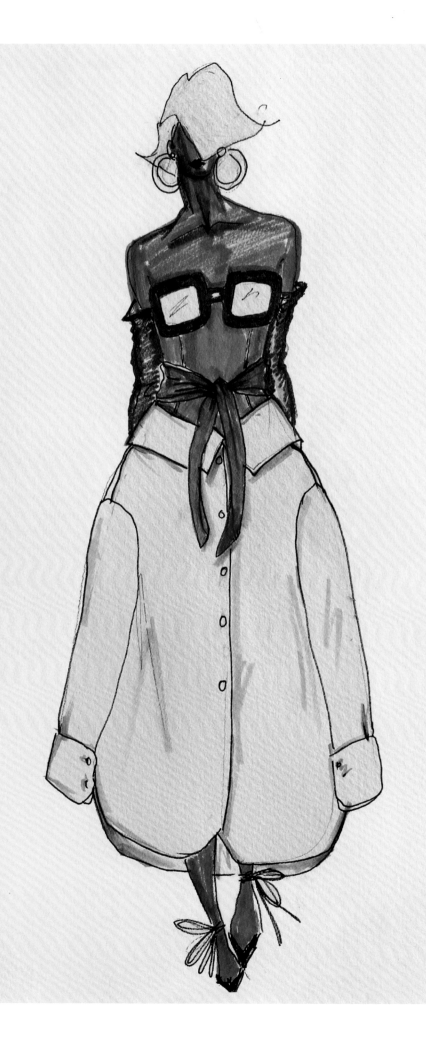

Working with Alber was the most terrifying and invigorating experience I have ever had. It was my dream; the catalyst for so much, personally and professionally.

I remember how, when stakes were high and deadlines were approaching, he would always bring his warm, empathetic eye to those around him, using humor and a wink and a tilt of the head to remind us of the absurdity of it all! To remind everyone around him that we are all human beings.

Alber was an outsized influence on my life and career. I am forever grateful and indebted to him. May his memory be a blessing to all who knew him, as it has been for me.

There's no formula,

when you are with
a group of people
who make you happy
to see every morning,

the sky is the limit.

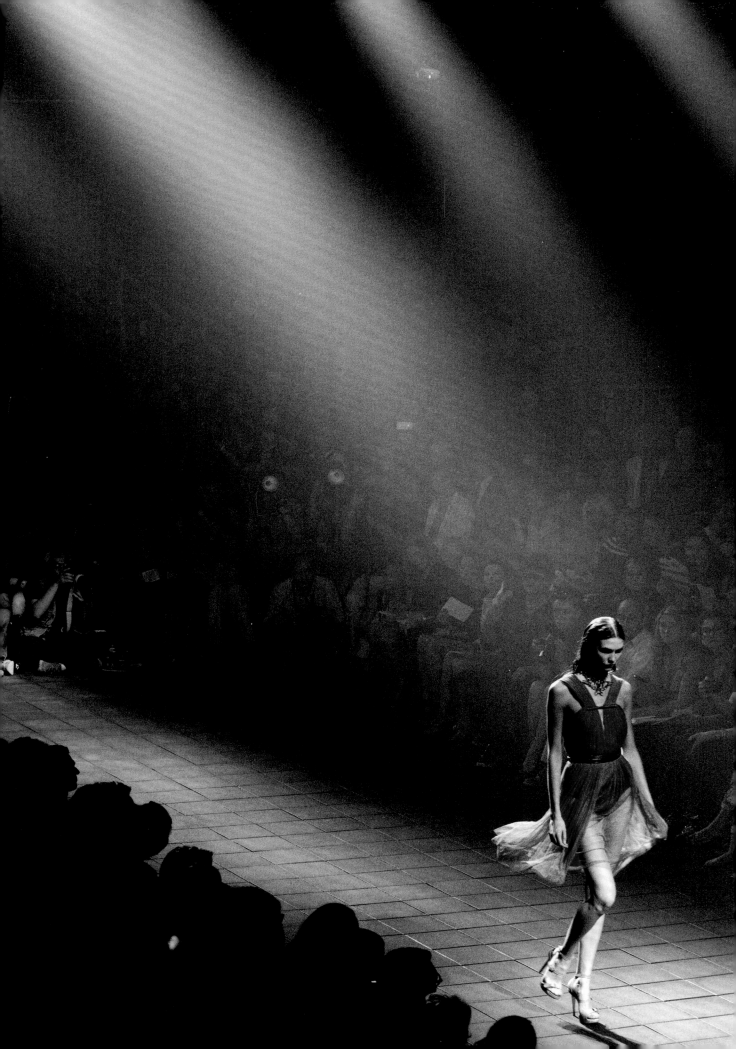

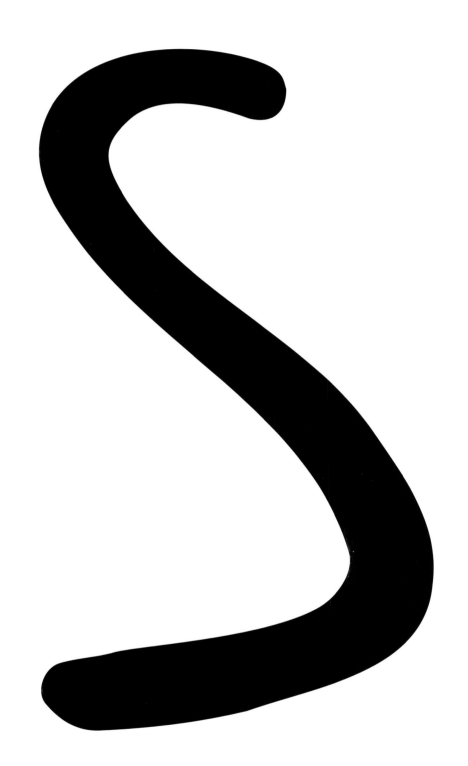

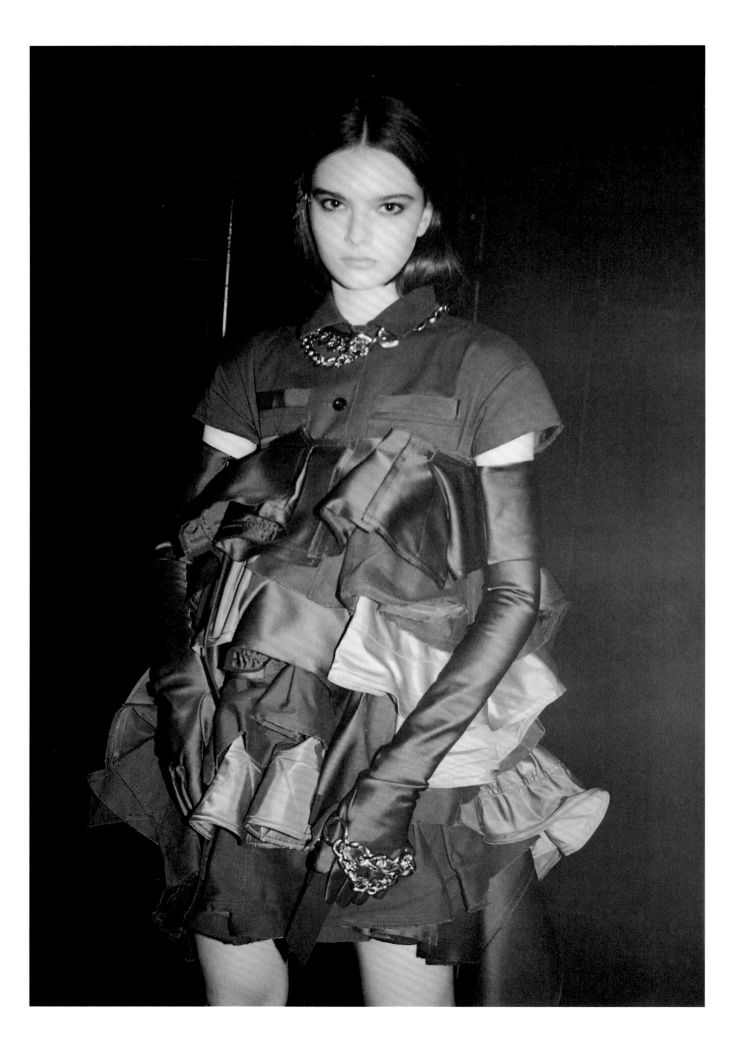

We miss you.
Creation always wins.

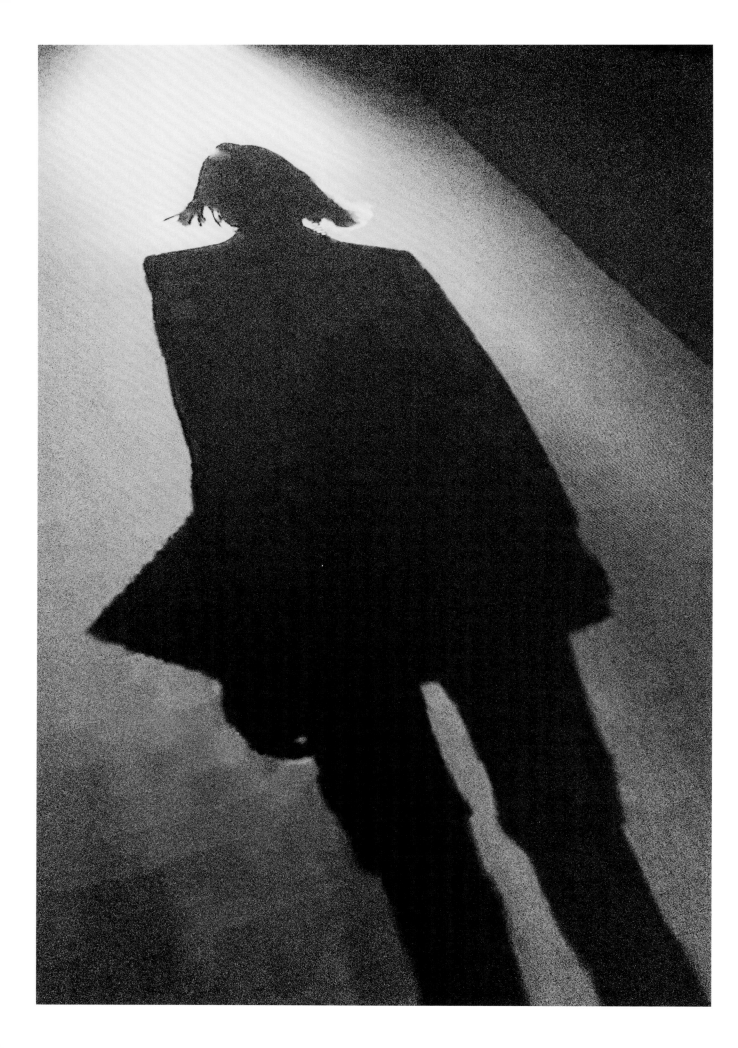

Tuxedo noir, chemise en popeline blanche, nœud en satin duchesse fuchsia.

Black tuxedo, white poplin shirt, fuchsia satin duchess bow.

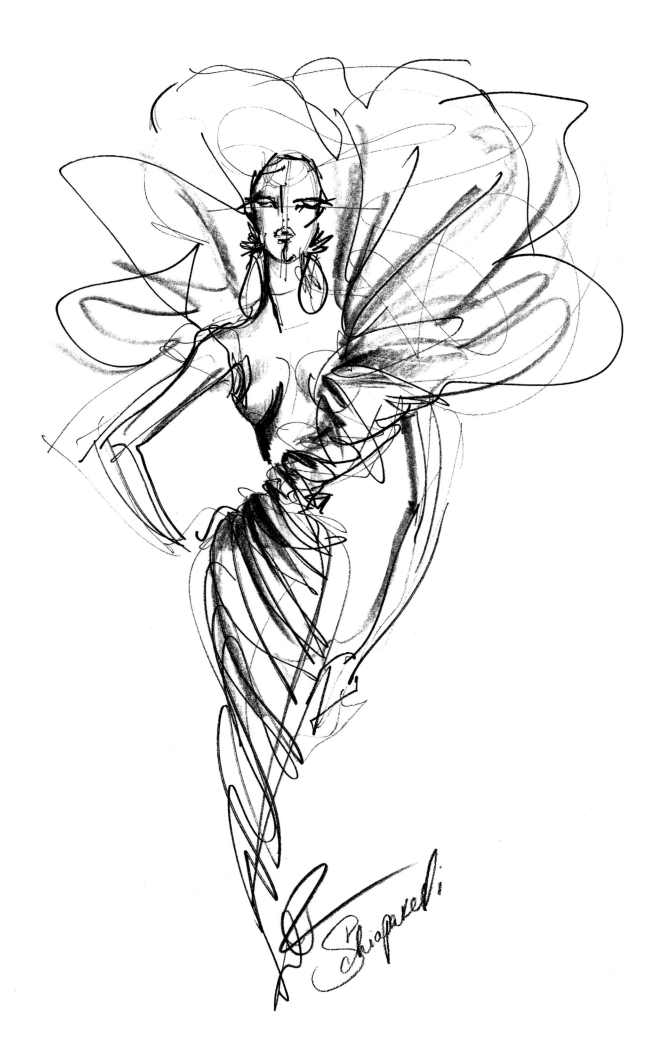

This is a creation that would not exist had I not been so inspired by Alber's work in my school years.

This is a tribute to his use of noir, his skill in bias, and the joy of explosive volume. A gown in black silk faille, overdyed and washed into his signature sueded matte silk. Alber and I share a particular affinity for bijoux, his influence honored here with a cast breastplate and oversized bijoux earrings.

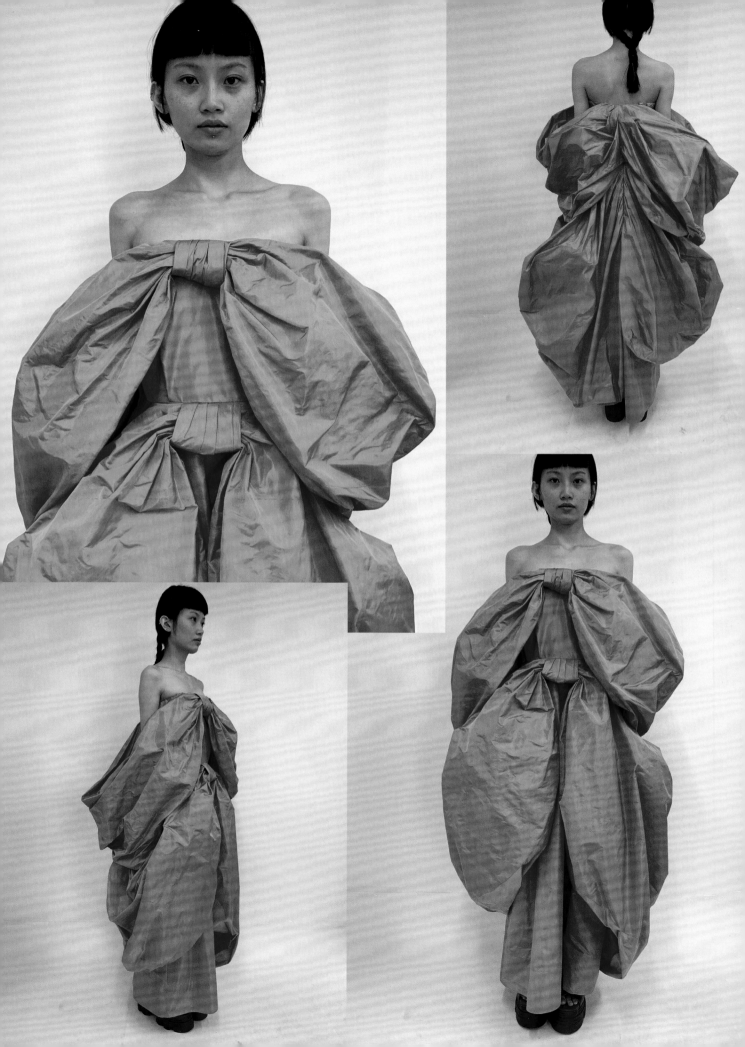

I remember being in contact with
Alber's work before we were friends
in person. I'll never forget 10 years ago
when my collection was first stocked
in DSM and I was right beside Alber's
Lanvin space with all the red rabbits and
I was so honoured to be in this company.
But we did not meet until sadly at the
Mass of my late professor, Alber's dear
friend Louise Wilson. Alber was so kind,
supportive, and full of admiration.
We always spoke freely about who
we were and our passion in what we
do to make things beautiful.

The dress is influenced by my SS21 collection and the Double
Giant Bow Taffeta dress, but translated into Alber's signa-
ture pink.

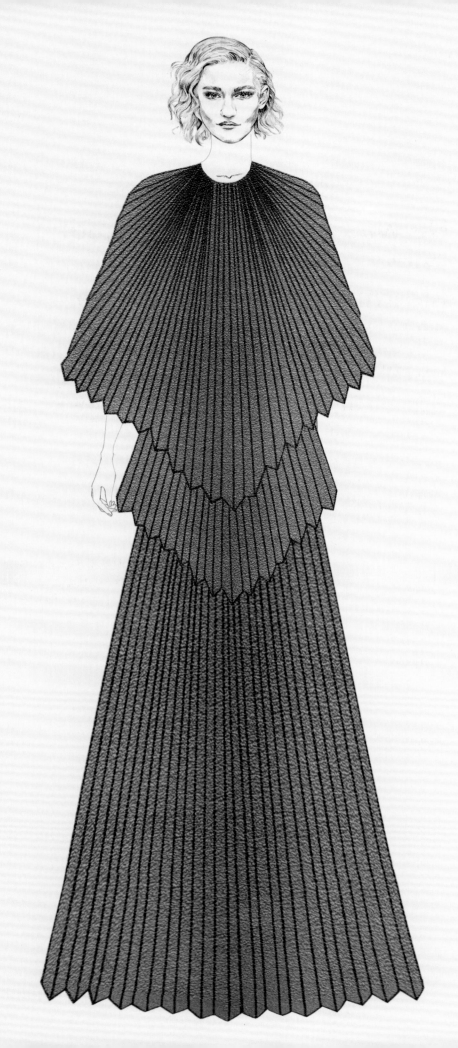

He was a light like no other
in the world. In fashion,
his immense talent shone
so bright that it tore up the
conventions and wrapped
a million souls in happiness.

Combining the glimmering vision of Alber Elbaz's AZ Factory
and the conscious values of the McCartney A to Z Manifesto,
this one-of-a-kind gold tiered dress is made of repurposed
materials.

Tribute to Alber era: Guy Laroche Season: 1997 — 98 A / W. A blouse and pleated skirt set, created in recycled satin in a pearly-white colour. The blouse features a fake pocket that looks like it's stained in Yves Klein Blue ink, a nod to the sense of humour I feel Alber's clothes had. The pleats on the skirt feature a jagged and asymmetrical hem. The white ostrich feather hat is created in collaboration with South African milliner Crystal Birch. We both were and will always continue to be fans of Alber and his contribution to fashion and the self.

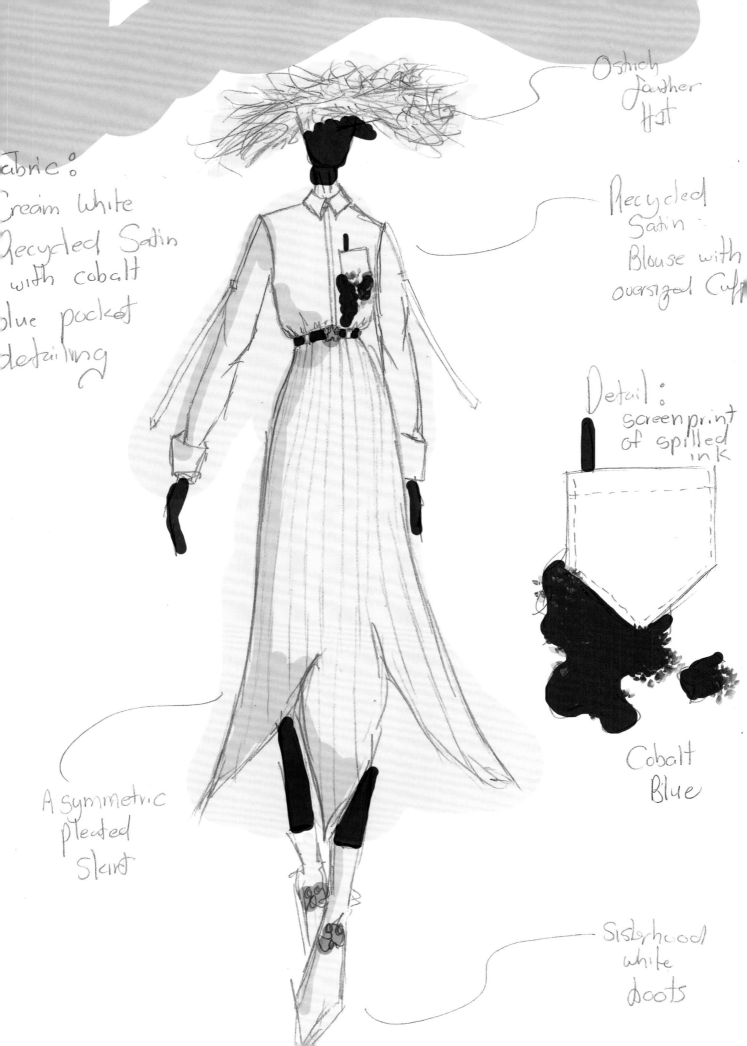

Ostrich
feather
Hat

Recycled
Satin
Blouse with
oversized Cuffs

Fabric:
Cream white
Recycled Satin
with cobalt
blue pocket
detailing

Detail:
screenprint
of spilled
ink

Asymmetric
pleated
Skirt

Cobalt
Blue

Sisterhood
white
boots

Alber was a true individual...
A true creative...
He represented pure joy...
both in life and in his
collections...

We all will remember the
joy that will continue on...

In homage to his friend Alber, Thom Browne created a cus-
tom evening look with a special personal detail. The gown,
in layers and shades of gray wool, tulle, and silk taffeta, fea-
tures a large bow across the front, as a loving nod to Alber's
appreciation of the bow tie.

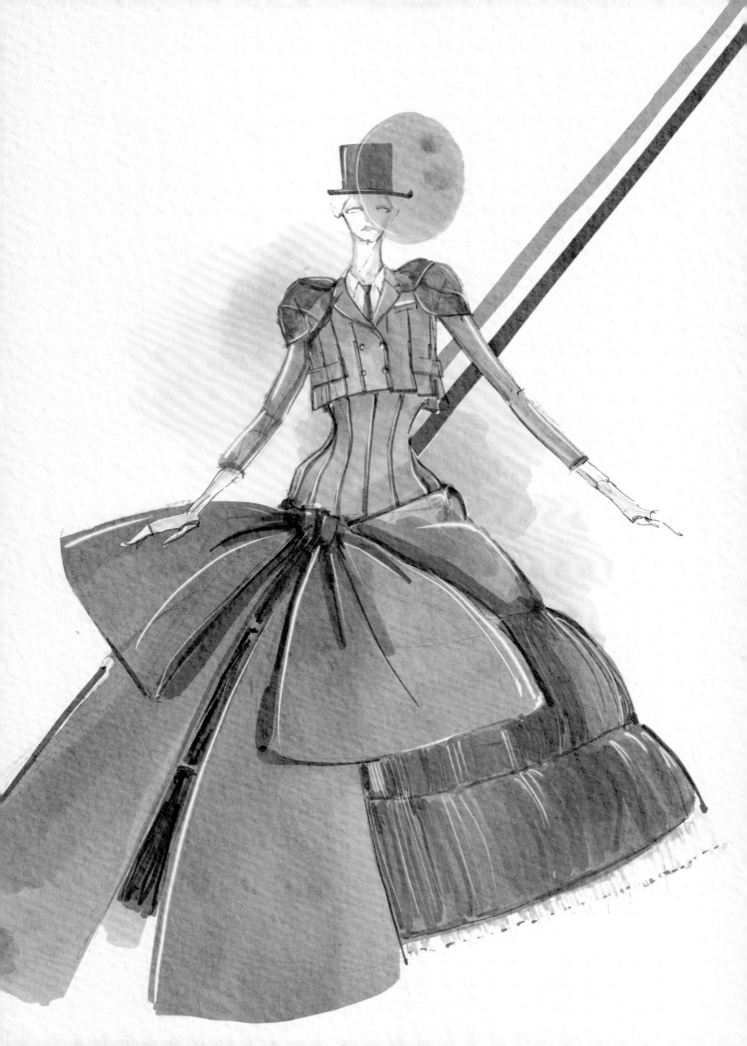

Alber is definitely one of the legendary designers of fashion history. His dresses taught me how to play with colors and how to make women's bodies look beautiful. I miss his designs so much.

This look is inspired by Alber's Lanvin 2012 AW Collection. I took the design and created a dress with my signature ruf-fle technique.

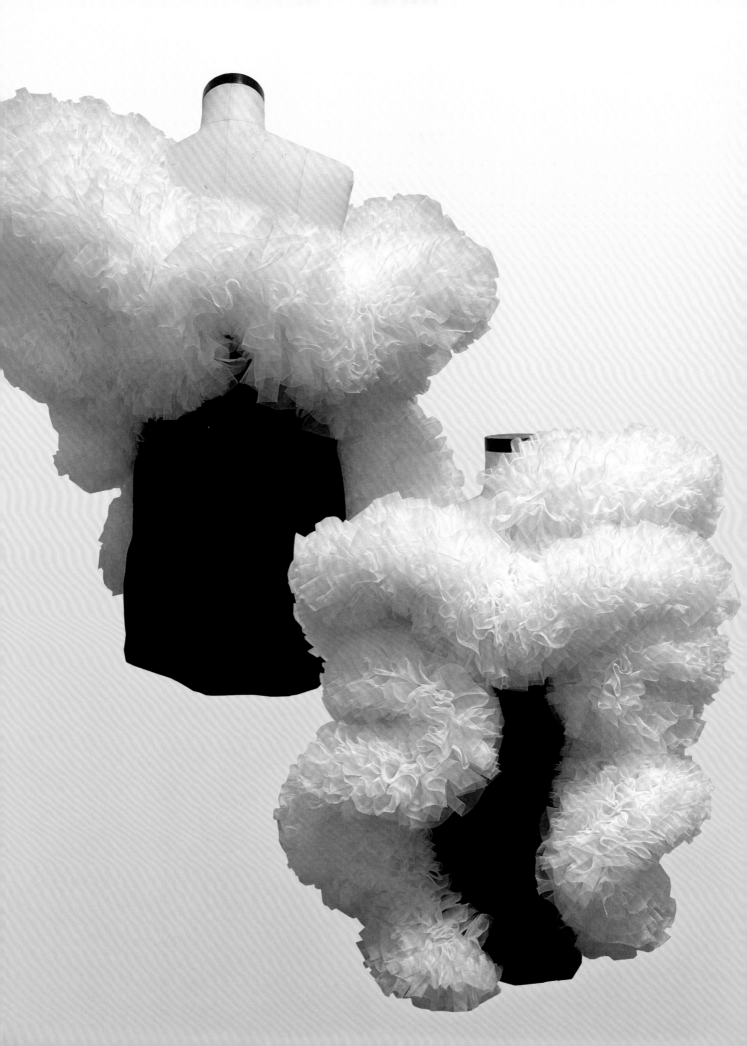

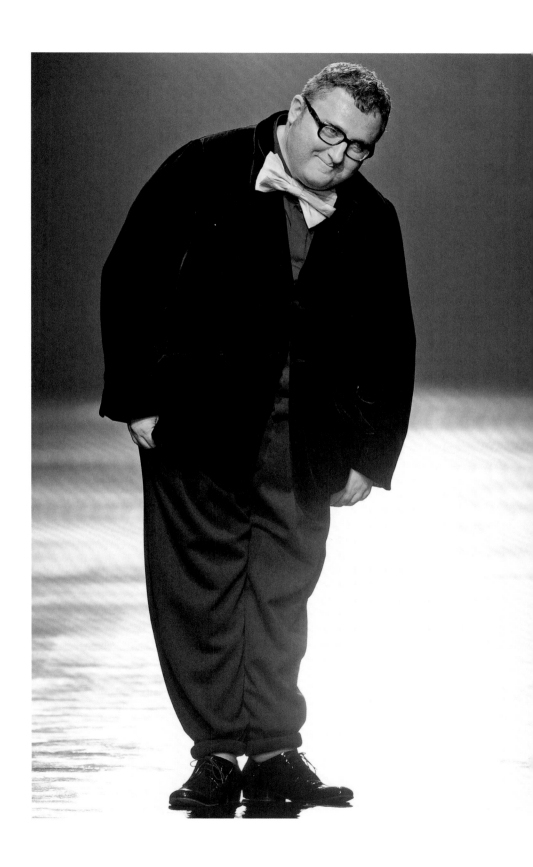

Alber Elbaz, 2008

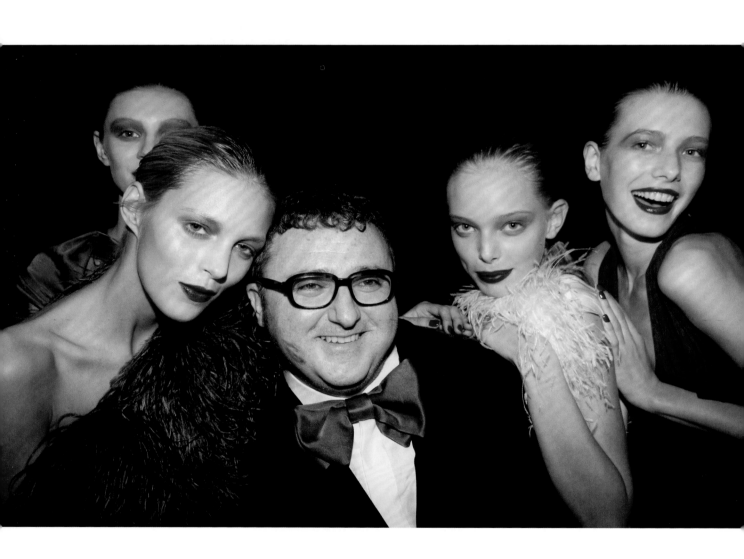

Alber Elbaz for Lanvin, 2007

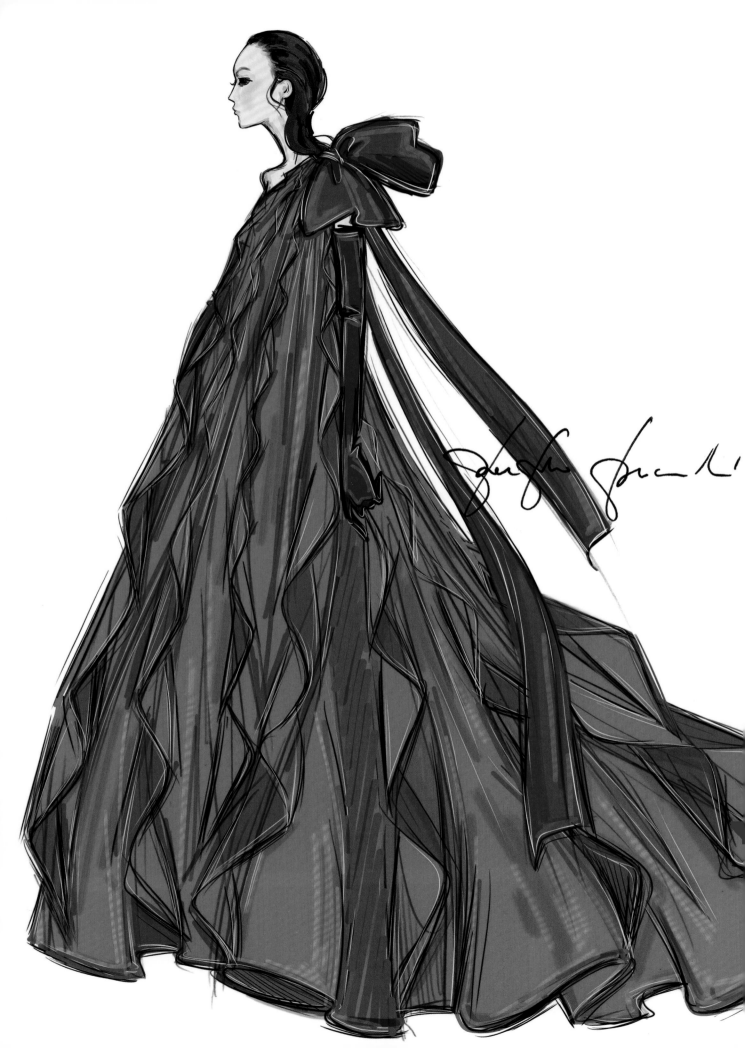

People define their self through actions.
Not words, not wishes, not good
intentions, but actions. For my first
solo show, Alber sent me this 'custom
couturier apron.' He made it: he spent
his time to decorate, stitch, and
embroider something that was for my
eyes only. He didn't need spotlights to
be a good person, he was, period. He was
the most unselfish human being that
I have ever met and his generosity was
also part of the way he approached
fashion. He was committed, heart and
soul, to his job — fashion was a mission
to him and I don't know if our system has
rewarded him sufficiently. Maybe not.
So I am more than happy to celebrate
him at any given time. I love you Alber.

One of the things that I have always loved about Alber's
design was his ability to create lightness and some sort of
candid sensuality. His huge faille dresses were at the same
time seductive and gentle… so for my creation I chose a pink
faille fabric which was overwashed to create a unique tone
of pink. It's one shoulder, of course, then there are ruches,
a fuchsia ribbon, and burgundy leather gloves. In some way I
wanted our classic signature elements to meet in one piece.
It is, in the end, a way to feel him near, now. I hope you like it,
Alber. With love, always. / PP

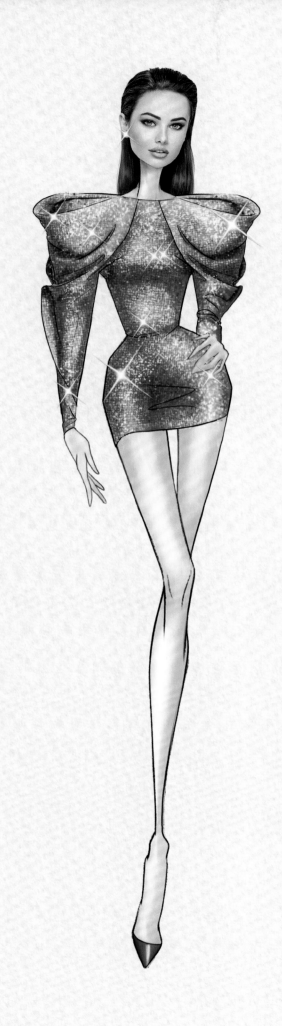

In tribute to the remarkable Alber Elbaz, this dress perfectly marries his style codes with an iconic Versace silhouette. Alber loved to play with volume and this design incorporates his signature draped sleeves. The vibrant fuchsia color speaks to Alber's personality: uplifting, vibrant, and joyful. The piece's dazzling crystals will light up a room, just like the man himself.

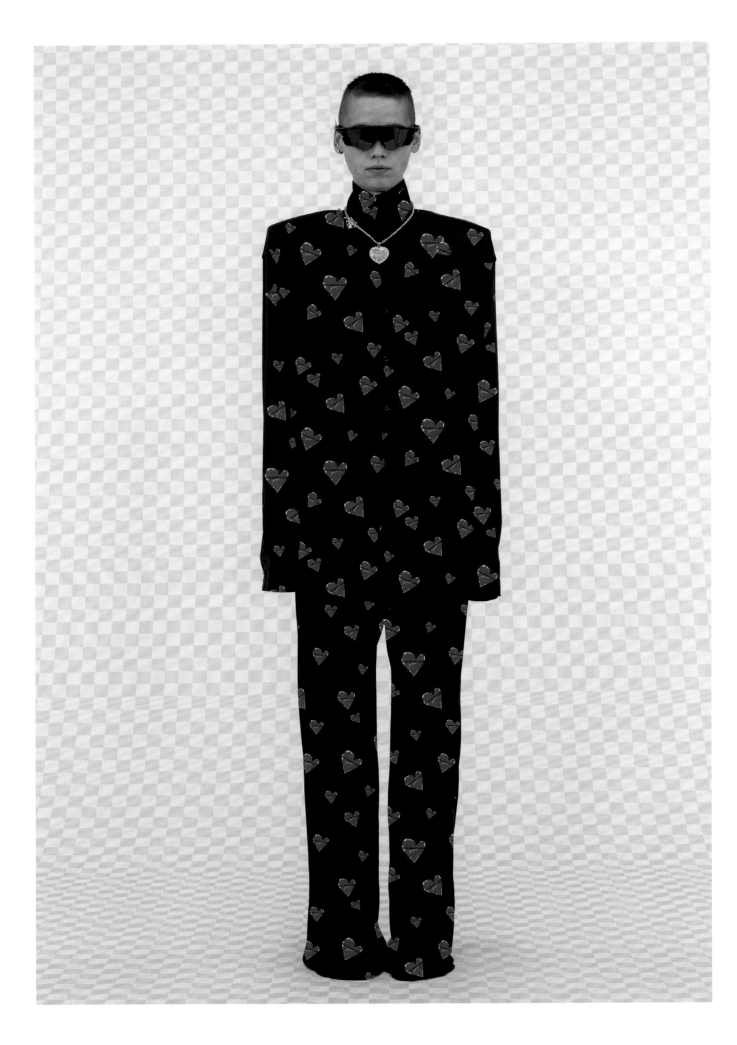

Alber touched hearts.
Every person he met felt
his love. Alber knew that
love would bring love.

The inspiration for the look
was love. The way Alber drew
it. His hand, his signature,
his love.

Alber was Love!
Love was Alber!

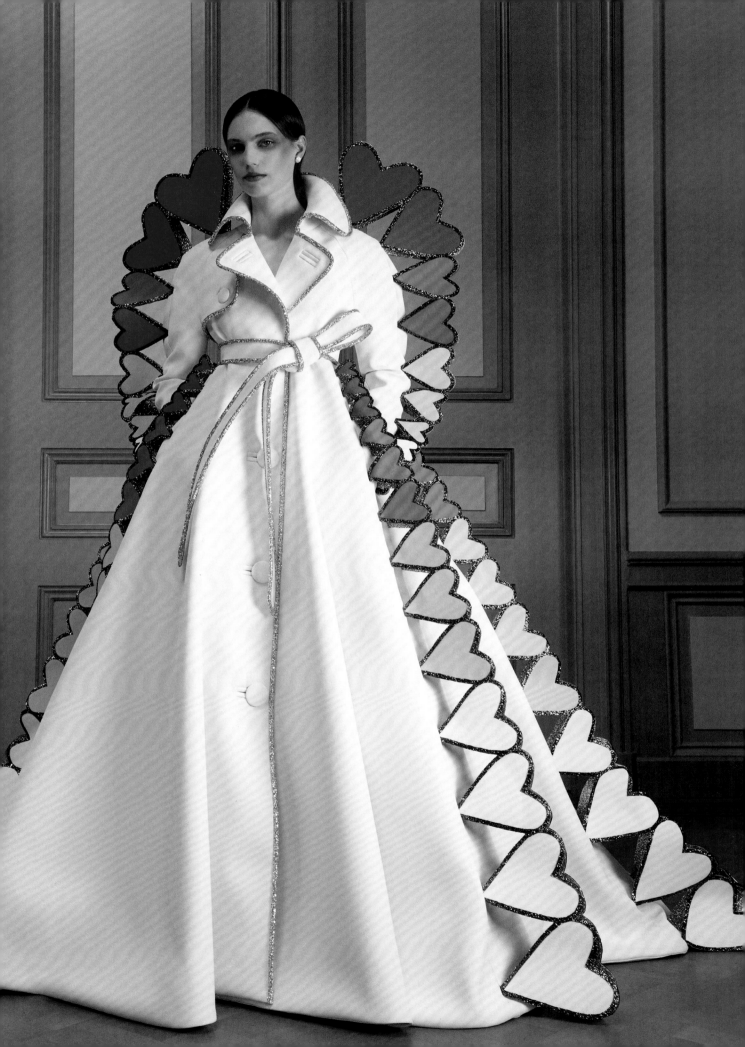

We attended a dinner where Alber was given an award. It struck us that the word most frequently used in his acceptance speech was 'love.' Love of fashion, love of people, love of craftsmanship... it felt like a plea for softness in a harsh commercial business. That is why we thought of a coat that wears hearts on its sleeves. Just like Alber did.

Love wardrobe, in these extraordinary times of change. This coat with dramatic train is crafted out of faux leather with elephant skin print, adorned with dozens of glittering hearts. The aura of hearts cascades down in a degradé of color and size. Iconic trench coat detailing is highlighted by crystal glitter.

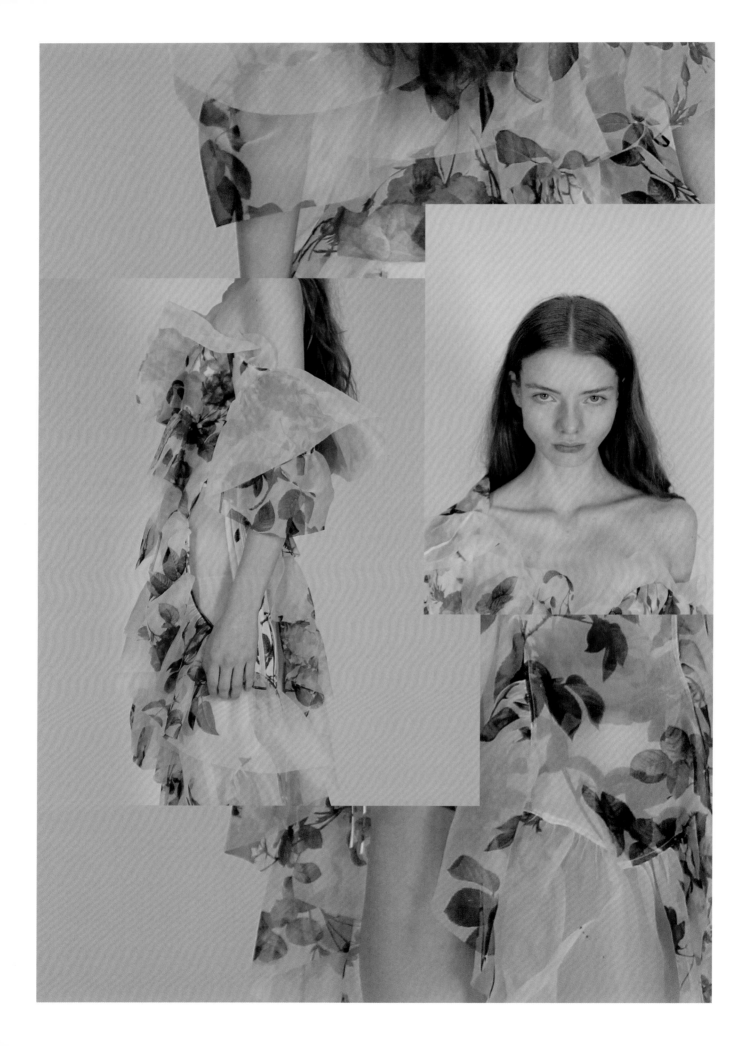

Every time we think of Alber, we think of frills and cocktail dresses, of feather-light and crisp fabrics, of silks and taffetas... He always adored women and wrapped them up in the most glorious fabrics. He loved flowers, and beautiful women, and beautiful things. We wanted to create something celebratory and in this spirit.

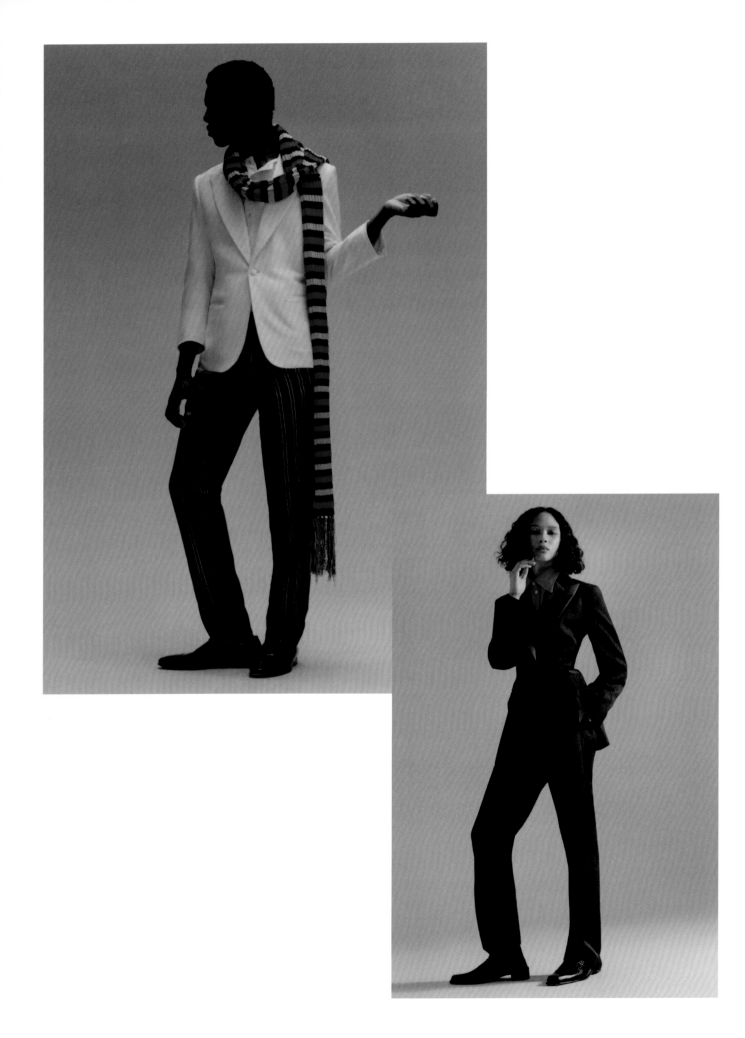

Alber brought a generosity of spirit to his masterful tailoring — an inspiring sense of romanticism and joy, fused with timeless elegance.

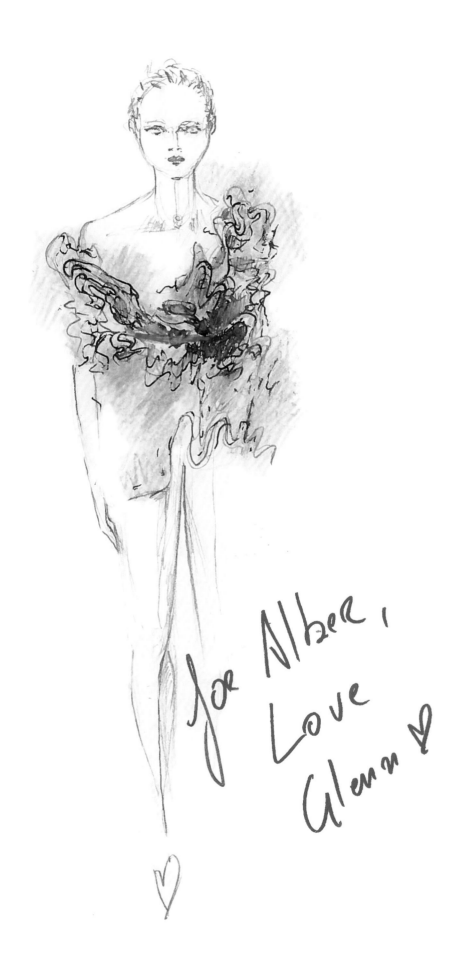

For Alber,
Love
Glenn ♡

♡

Glenn Martens was inspired by the draped movement and voluminous silhouette of Alber's candy-pink cocktail dress, in the iconic shot by Tim Walker. He extends these details by integrating pliable wires along the neck and waistline, which can be bent and twisted to create eclectic and exaggerated shape and volume.

Alber Elbaz, AZ Factory, 2020

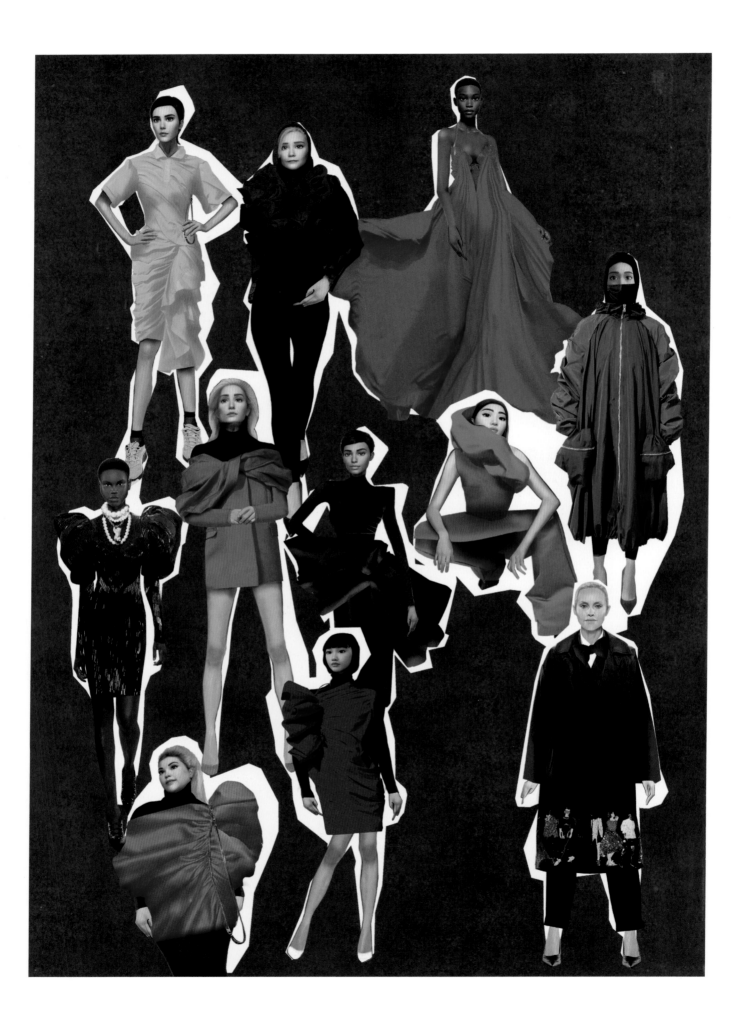

Colleagues produce, friends laugh, but families grow. They love unconditionally. They fight sometimes. They come together, always. Families CREATE. Alber always saw his team as family and, more than ever before, cultivating his AZ family was his guiding star for this crazy startup dream. As both the strict mother and the understanding father, Alber brought us all together as his loving adopted children at AZ Factory, as well as naming plenty of aunts and uncles who would often visit. For him, this was how you built the best team. Alber, we miss you. We present here what you started with us and what we finished for you as your AZ FAMILY.

Our beloved and generous founder's vision for AZ Factory kept us focused and passionately committed to deliver on his promise and his legacy that he left behind too soon. We created active silhouettes and forms using couture fabrics, with techniques anchored in the highest disciplines of style and savoir-faire. When looking for the red-thread, we pushed even further, delving into the innovative Athletic Couture direction that Alber dreamt of for AZ Factory. For you, Alber, we followed our own intuition to find what we believe is relevant in this homage to you. Alber, we miss you and we hope to make you proud.

When you walk, look in
five different directions:
Look straight because
you have to look forward.
Look back because you
have to remember where
you are coming from.
Look to the sides to see
who are the people that
are going to be next to
you if you need them.
Look down to make sure
you don't step on anyone.
And look up as you have
to remember that someone
protects us. This is, maybe
what life is all about.

Que
sera
sera

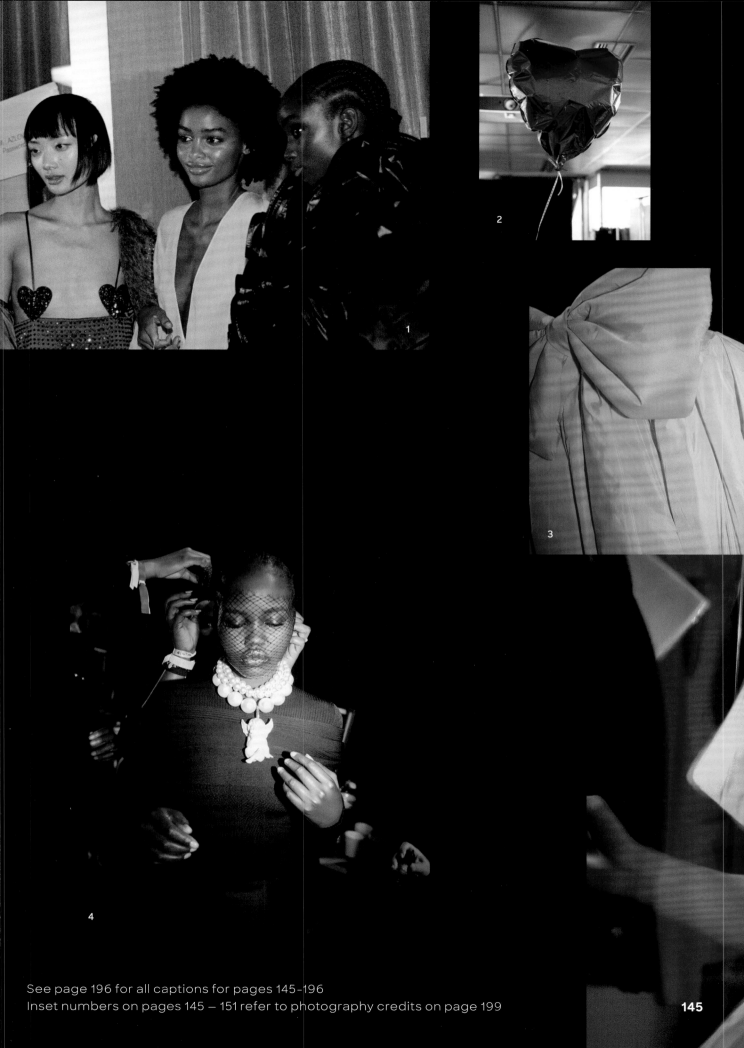

See page 196 for all captions for pages 145–196
Inset numbers on pages 145 – 151 refer to photography credits on page 199

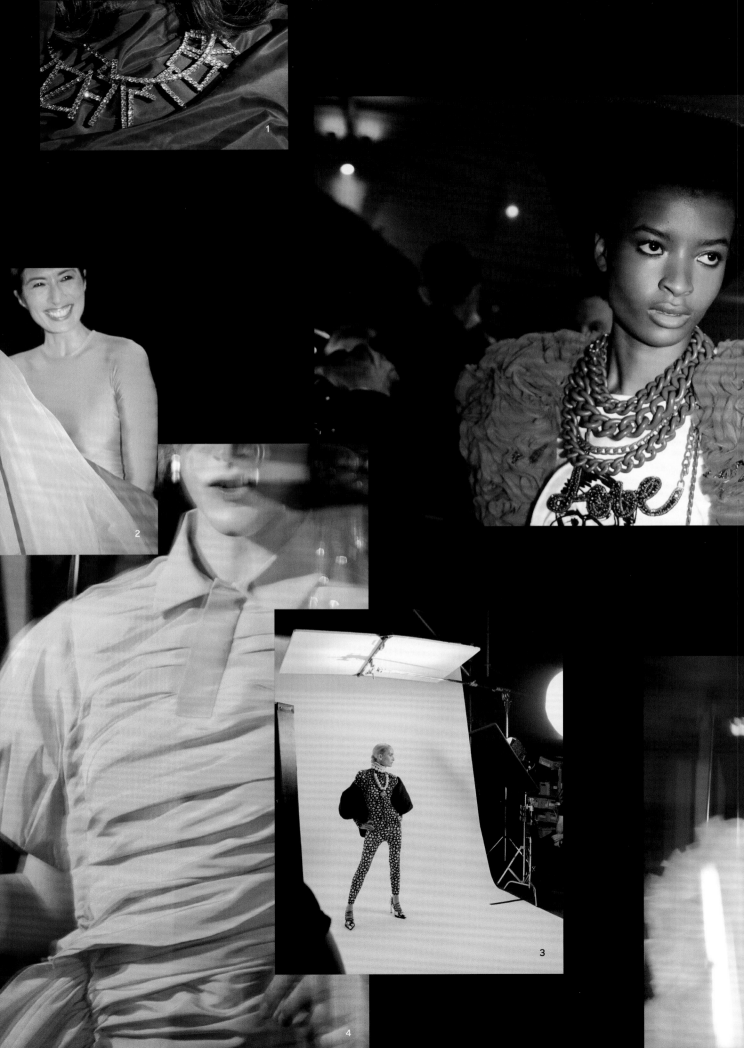

1

2

3

4

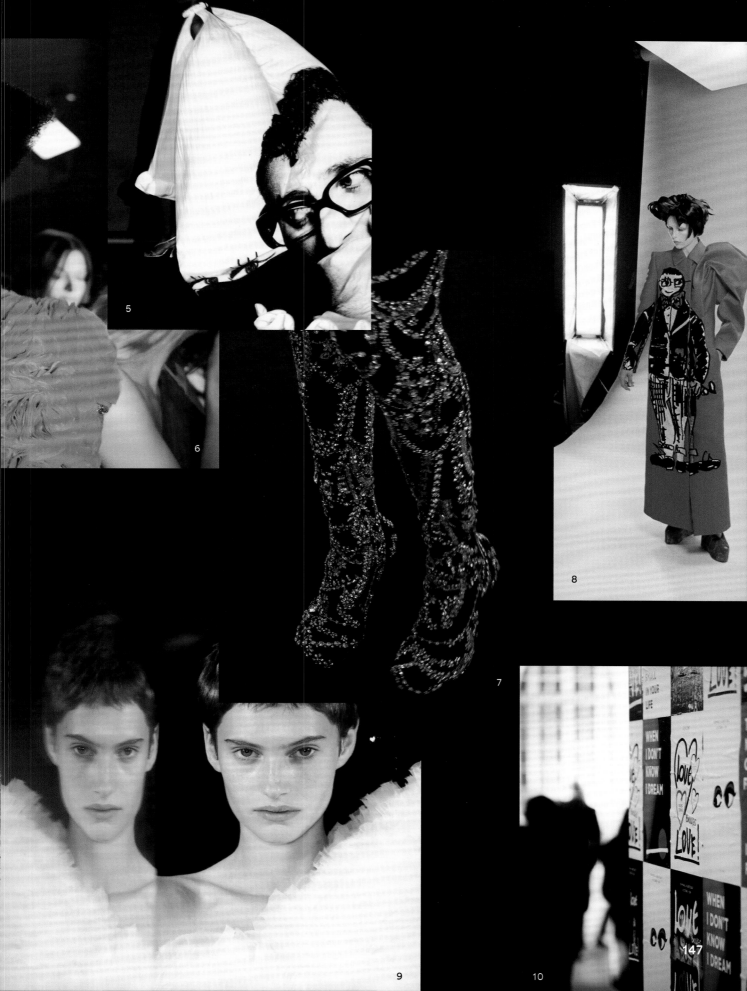

5

6

7

8

9

10

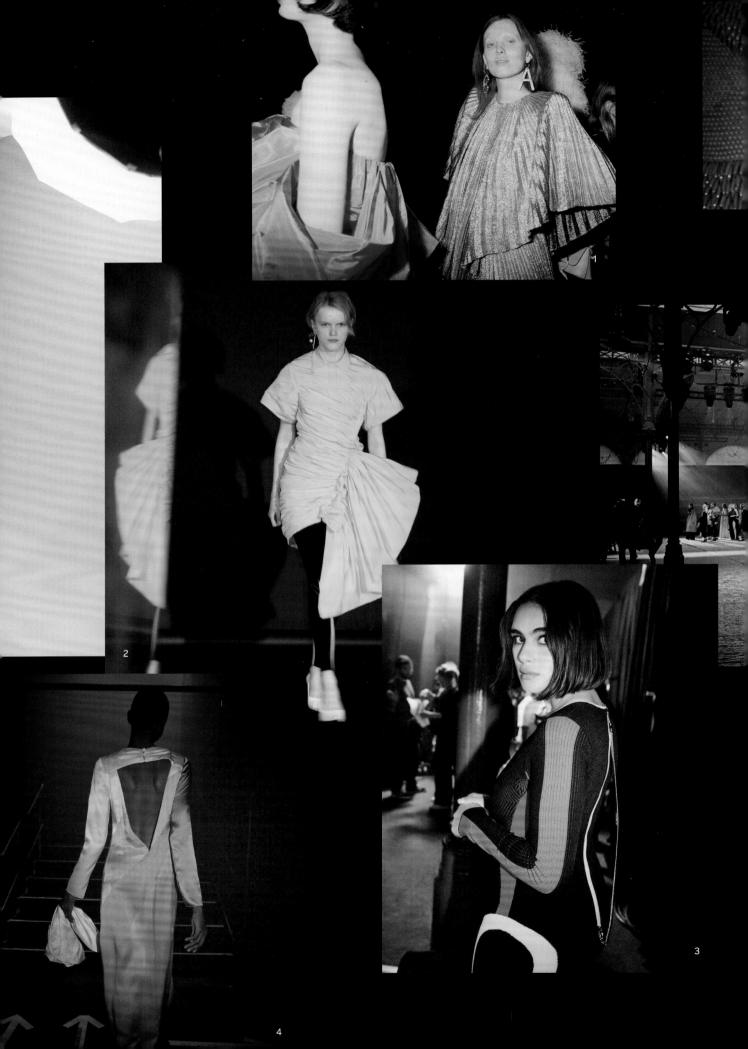

1

2

3

4

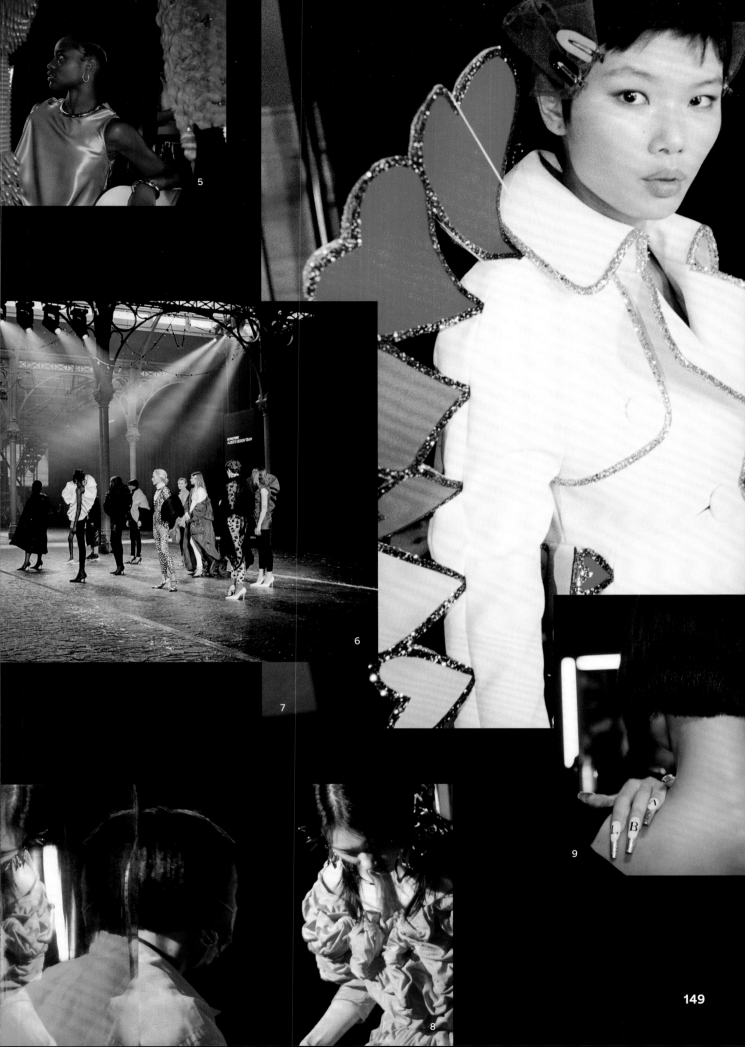

5

6

7

8

9

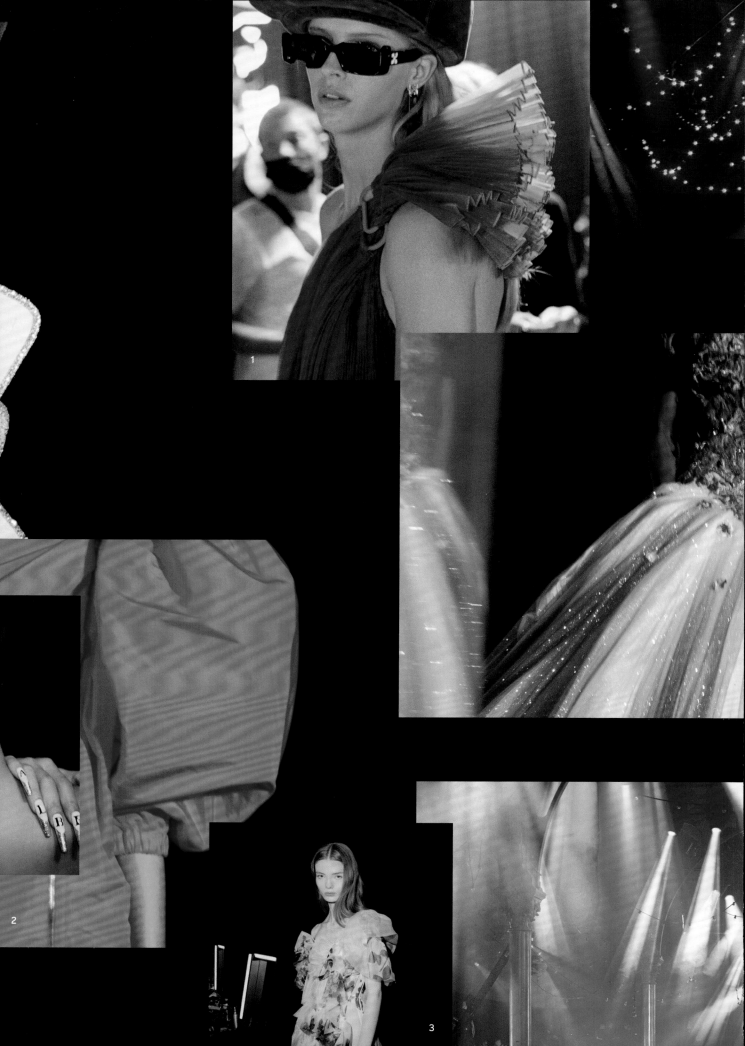

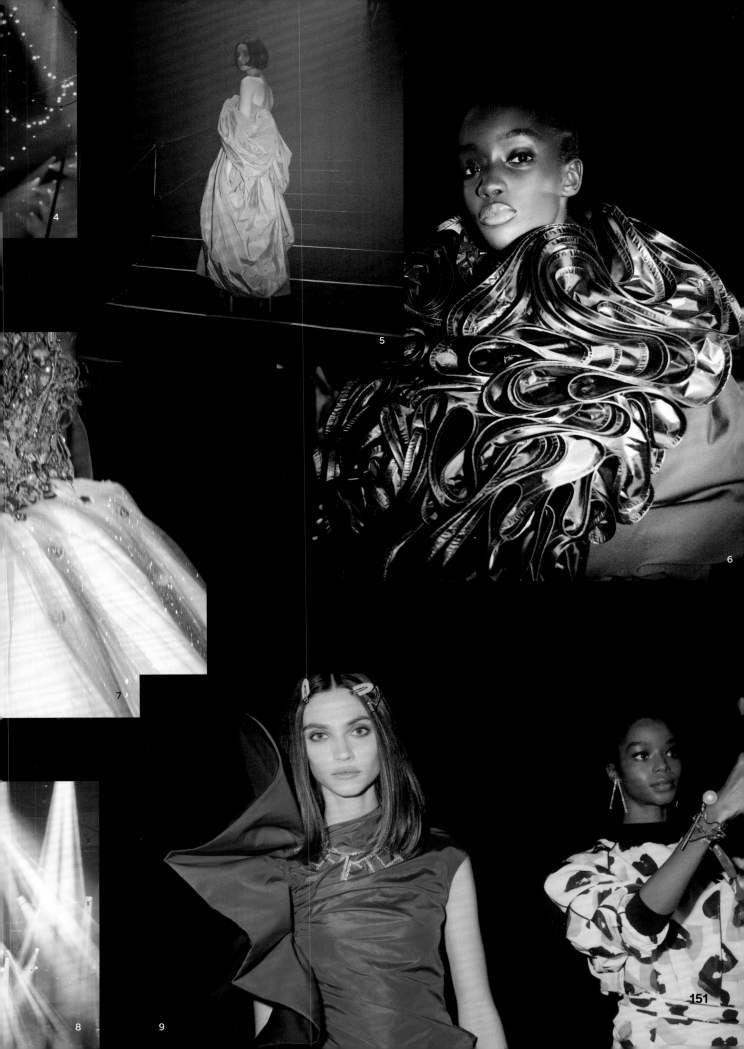

4

5

6

7

8

9

Love Brings Love

This evening, October 5th 2021, we witness this beautiful phrase become a powerful expression of love and respect by the industry in his honor. We are deeply moved and humbled to celebrate with you all and to pay tribute to our beloved Alber. Most of all, Alber would have been incredibly honored to be surrounded by his peers, colleagues, collaborators, friends, and family. Simply a beautiful *Love Letter* to Alber.

Alber was a family man at heart. He never forgot his roots. He cared for people like an obsessive parent, he loved his friends like his own brother or sister. With humility, humor, and plenty of generosity. He made us laugh... he made us cry... and he made us dream.... He made us just want to reach out and hug him. Alber, to me, was always just Alber... the same humble, funny, loving, and generous man I had met in New York City who remained by my side for these precious 28 years. For many years Alber wanted to bring together the Fashion industry as one talented group of individuals, to promote creativity and solidarity. Today in his honor, over forty of the world's greatest designers join forces to do just that.

Tonight, his dream becomes a reality. I know Alber would have been so happy and proud to be part of this beautiful family. Thank you. Thank you all for making Alber's dream come true.

Alex Koo
Alber's partner

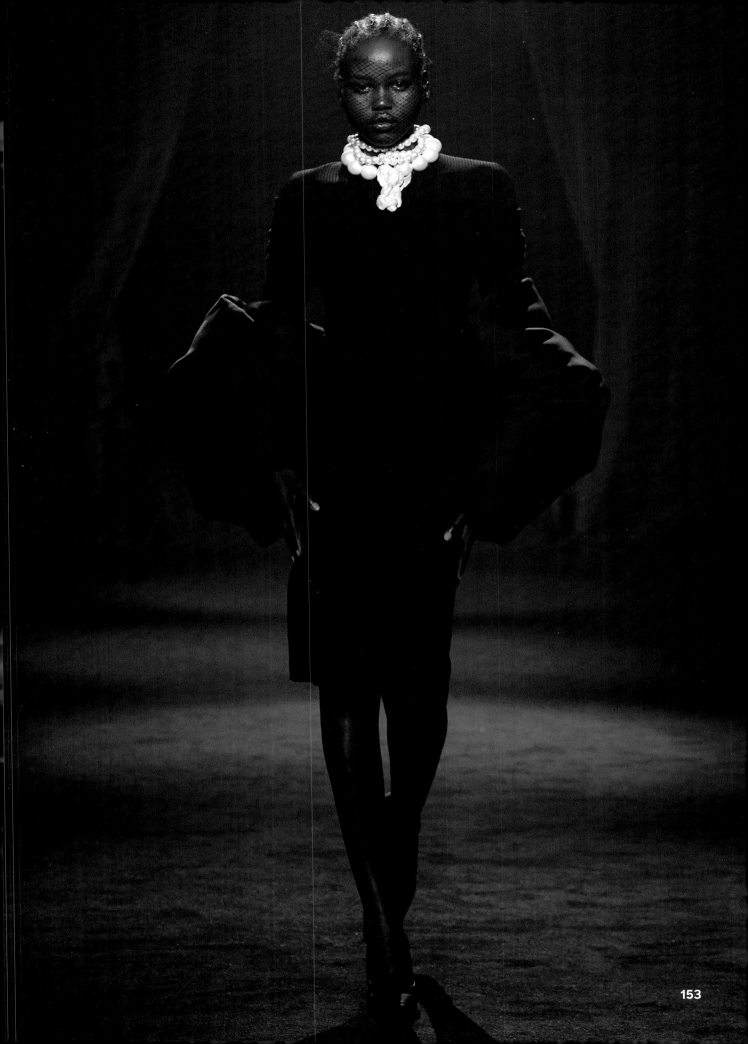

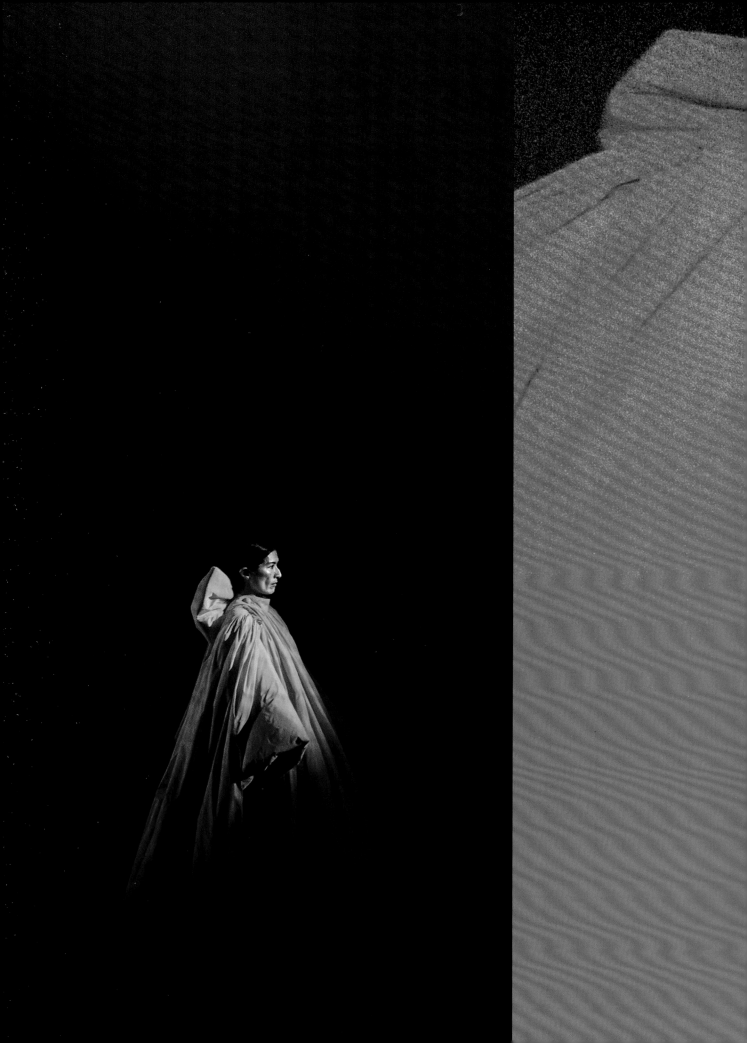

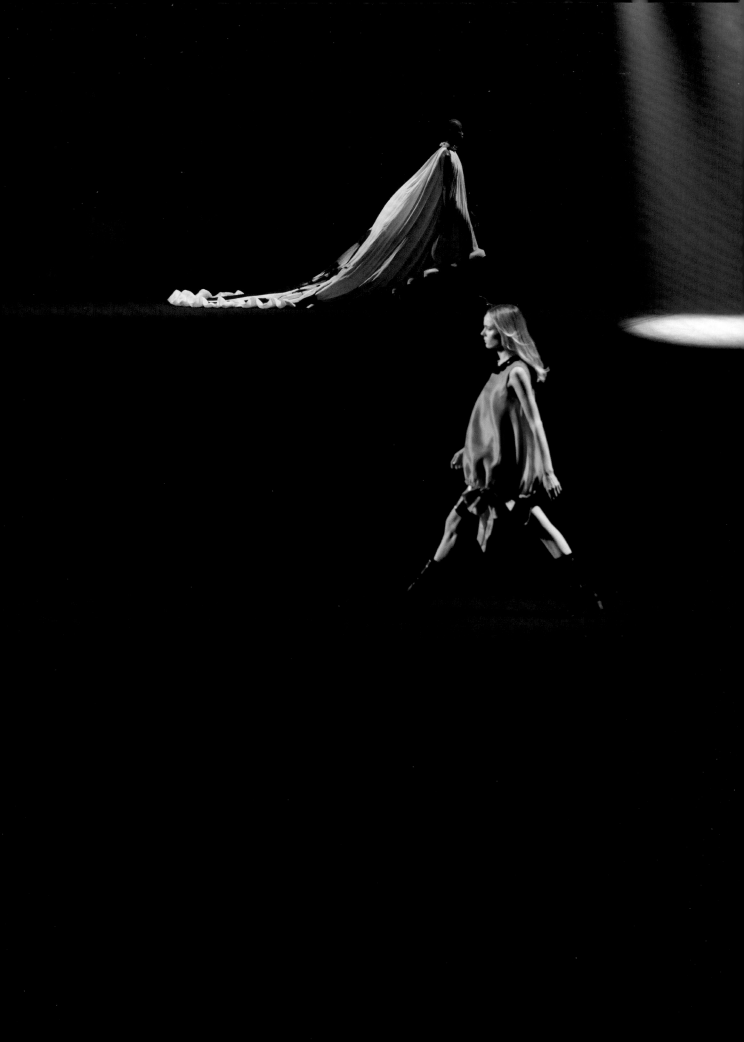

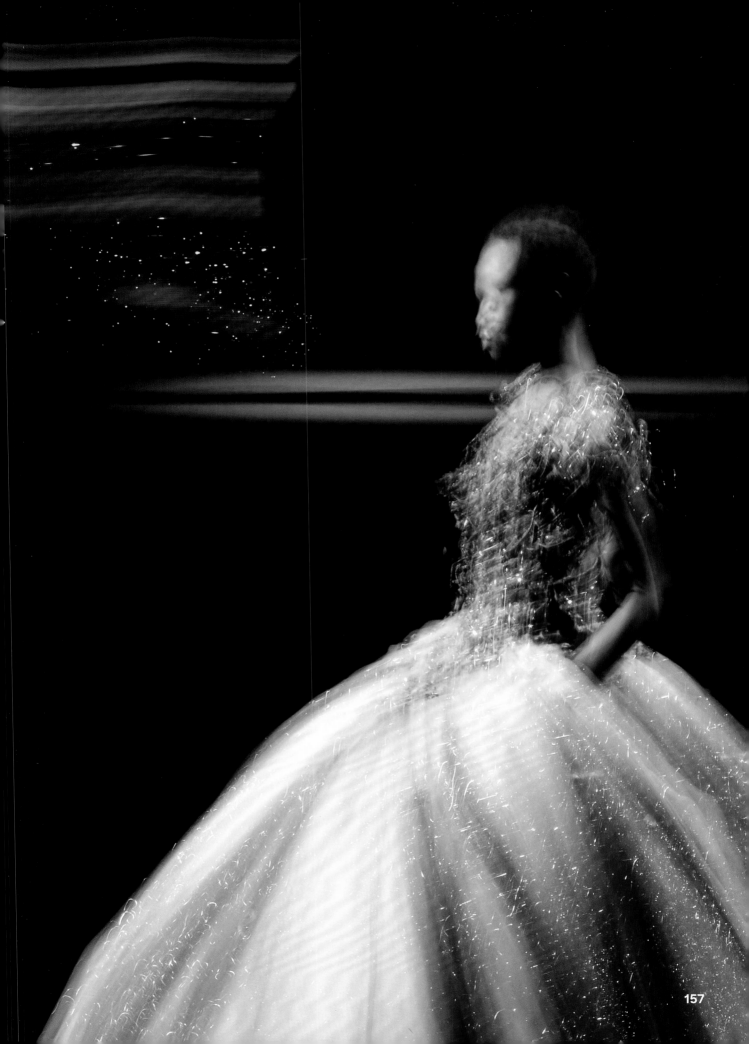

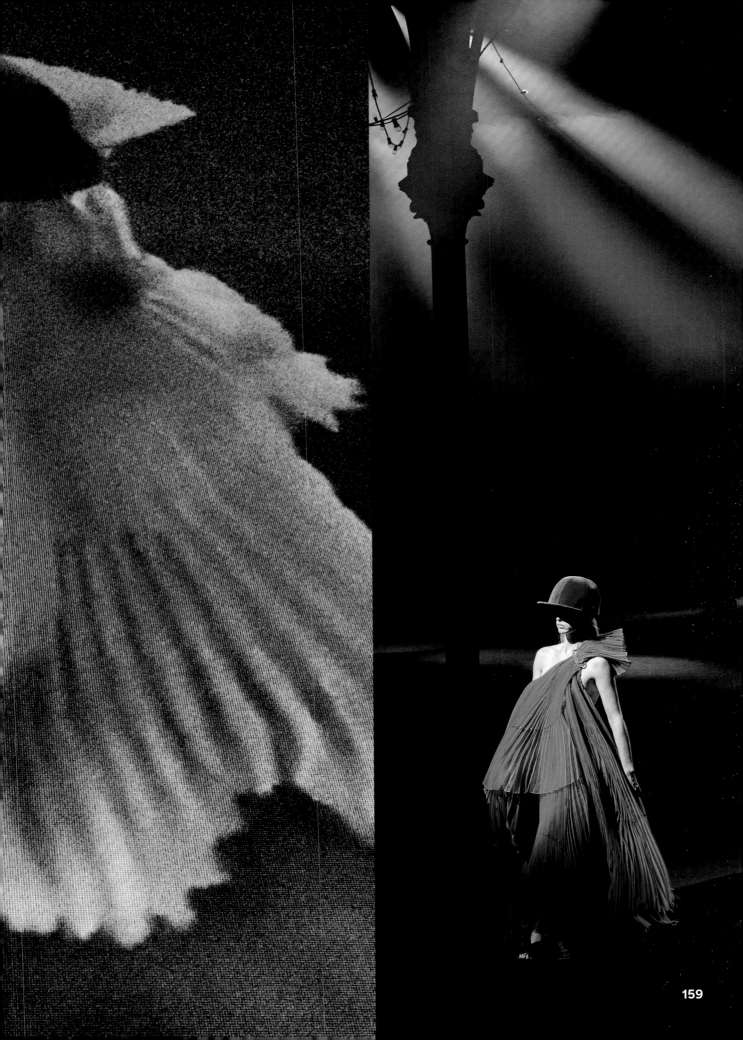

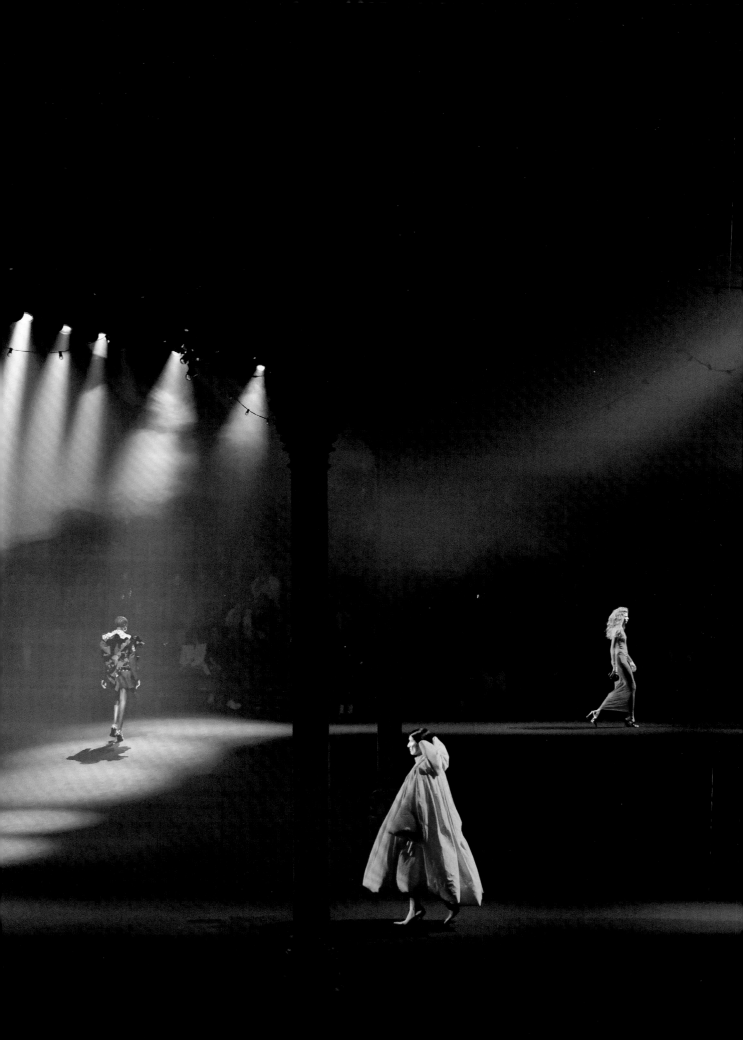

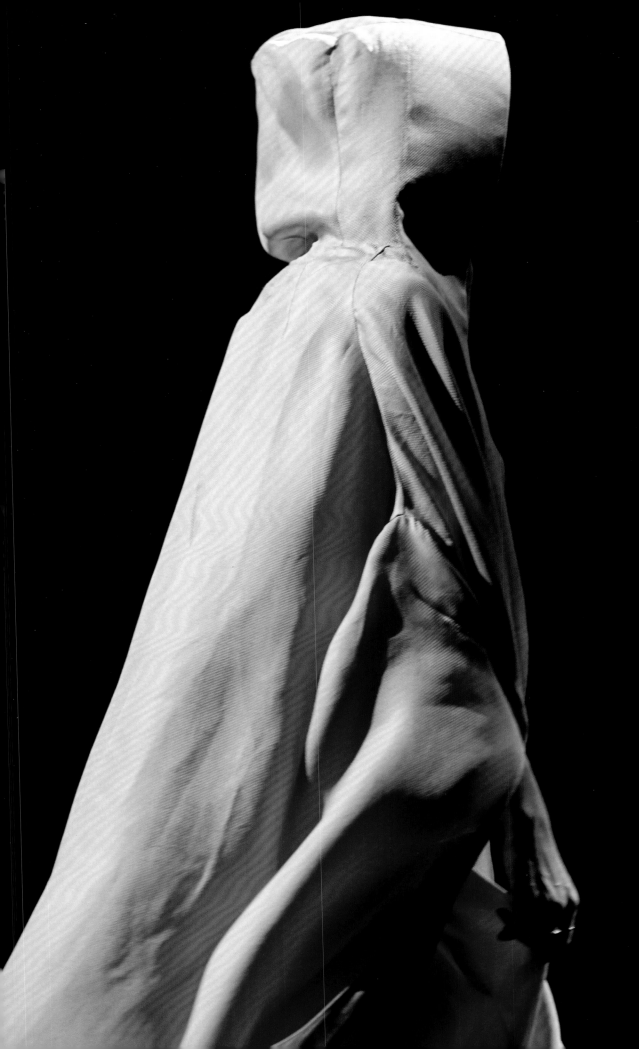

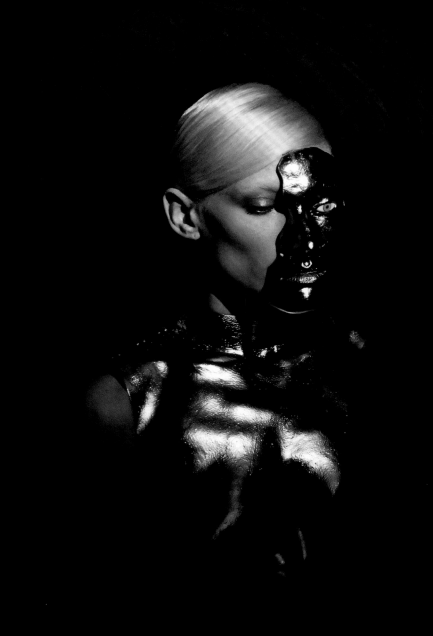

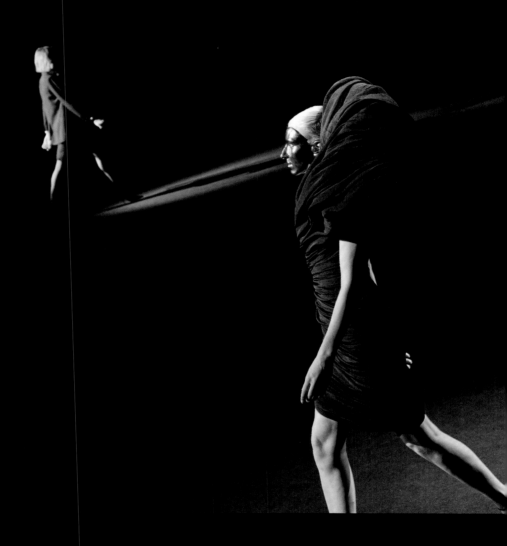

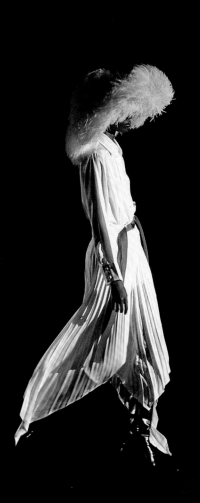

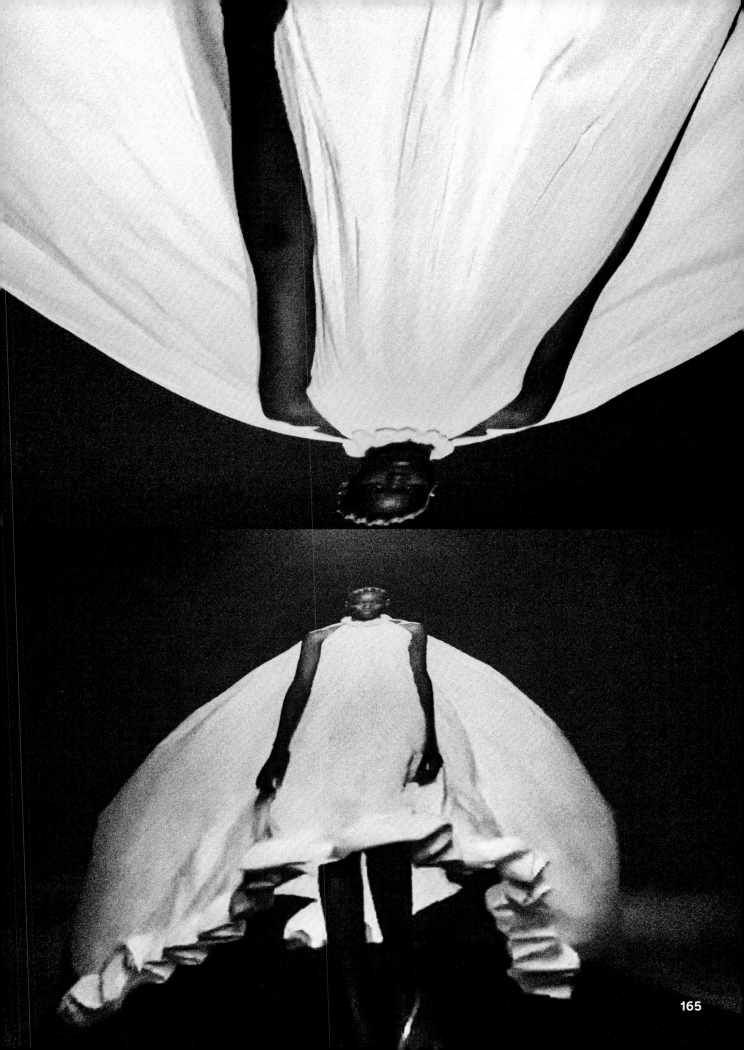

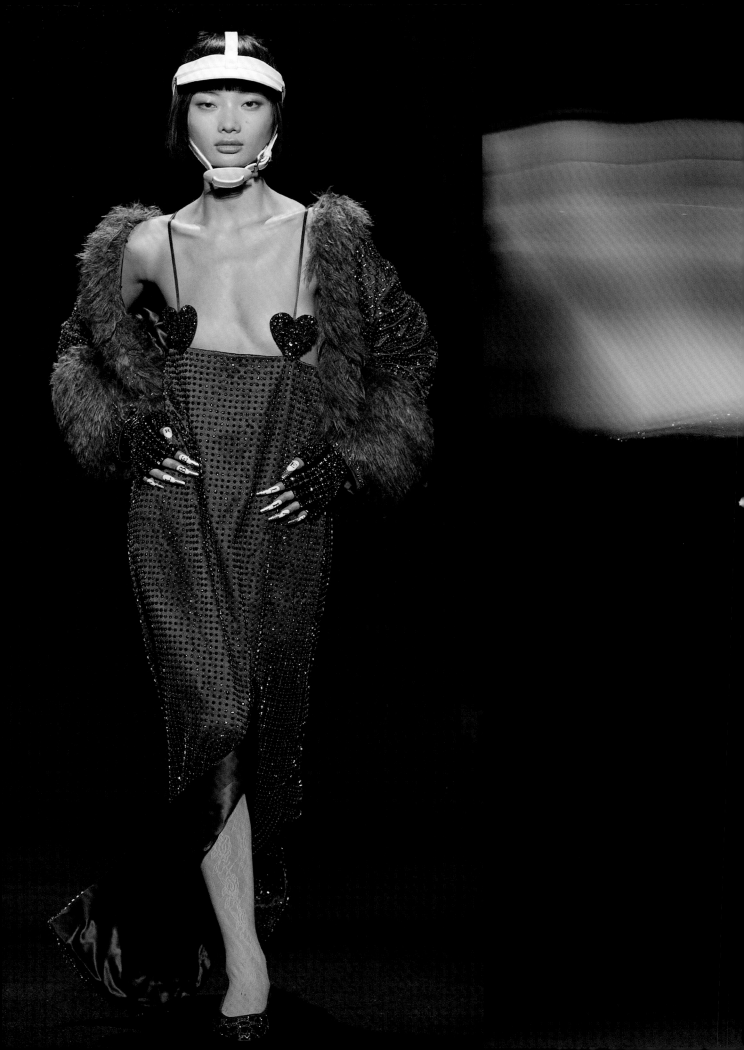

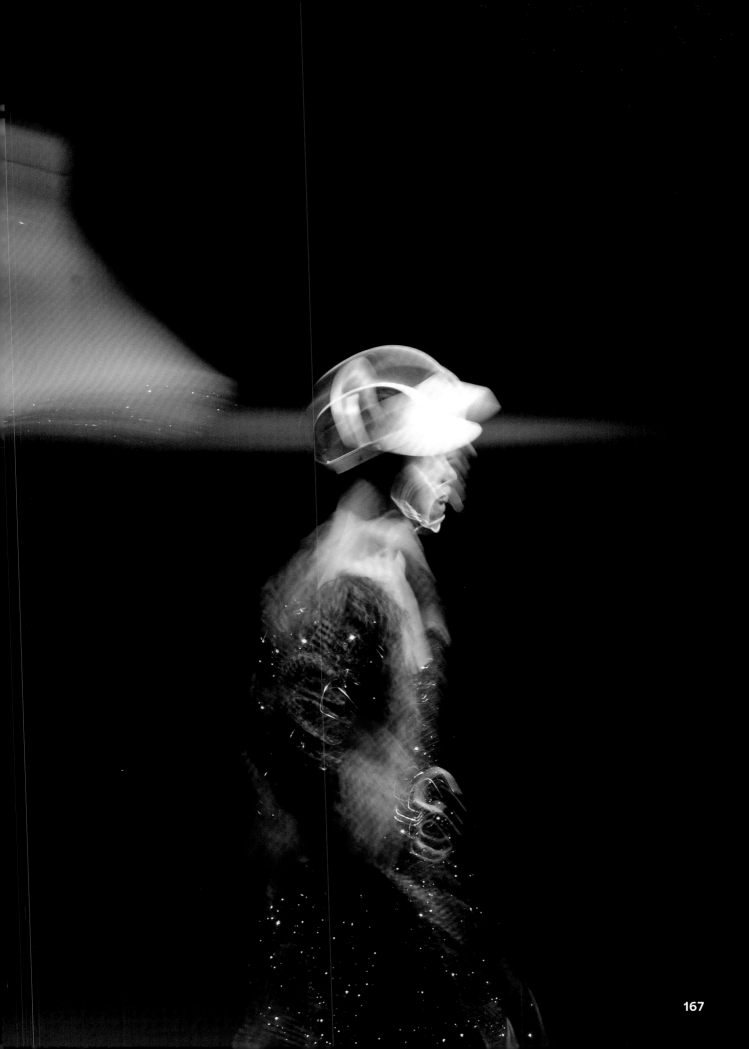

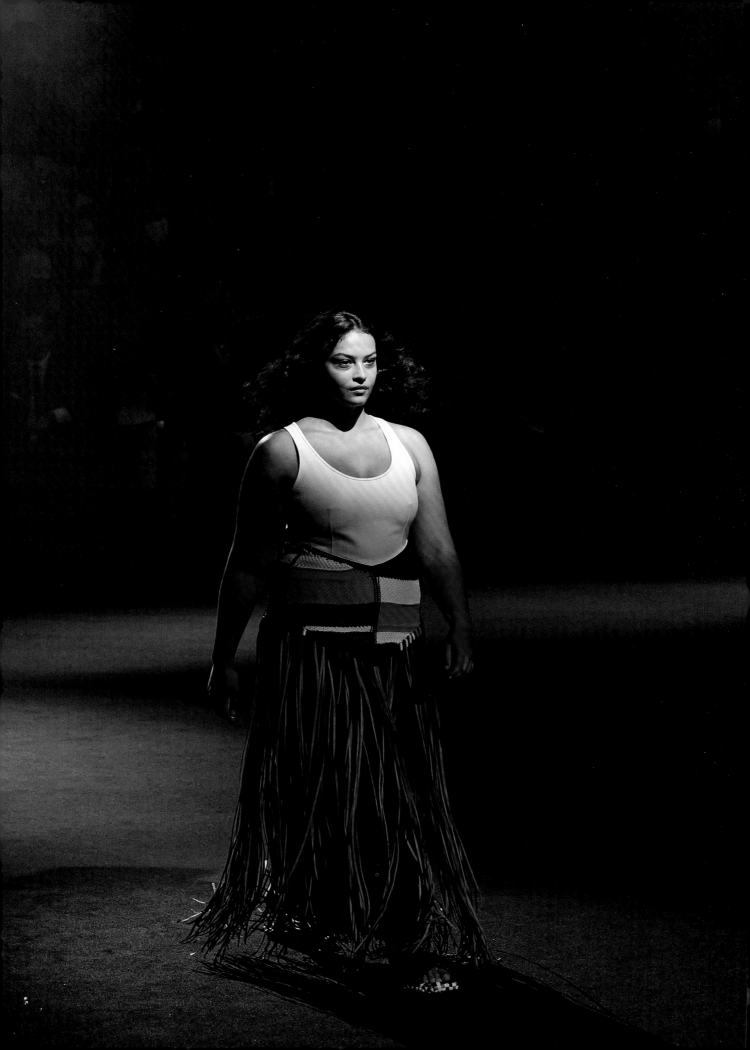

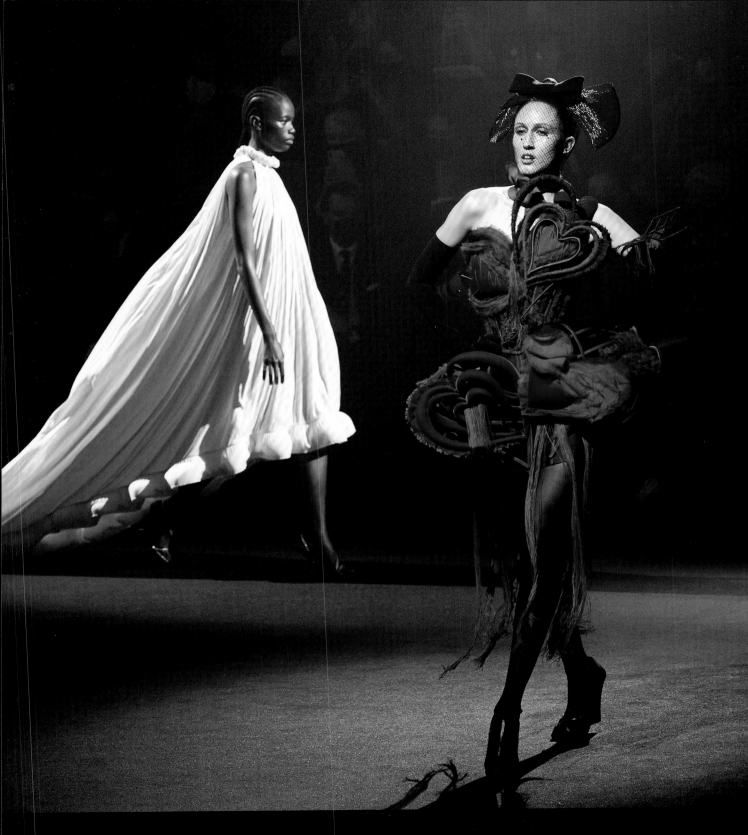

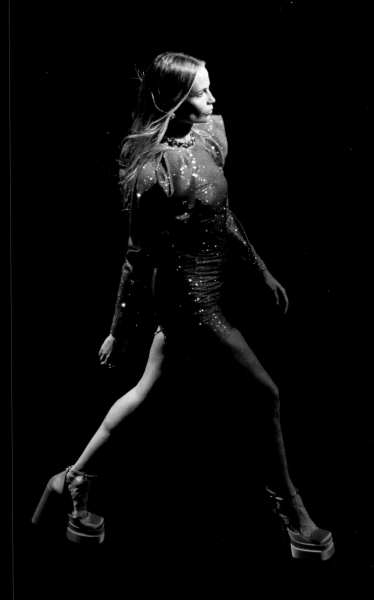

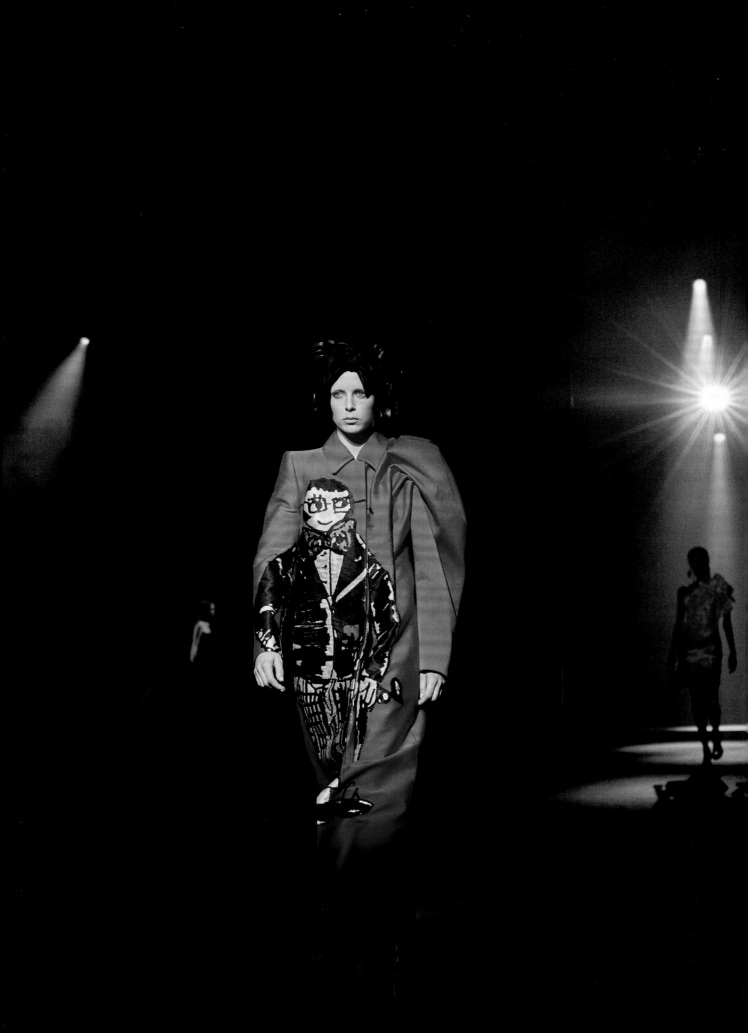

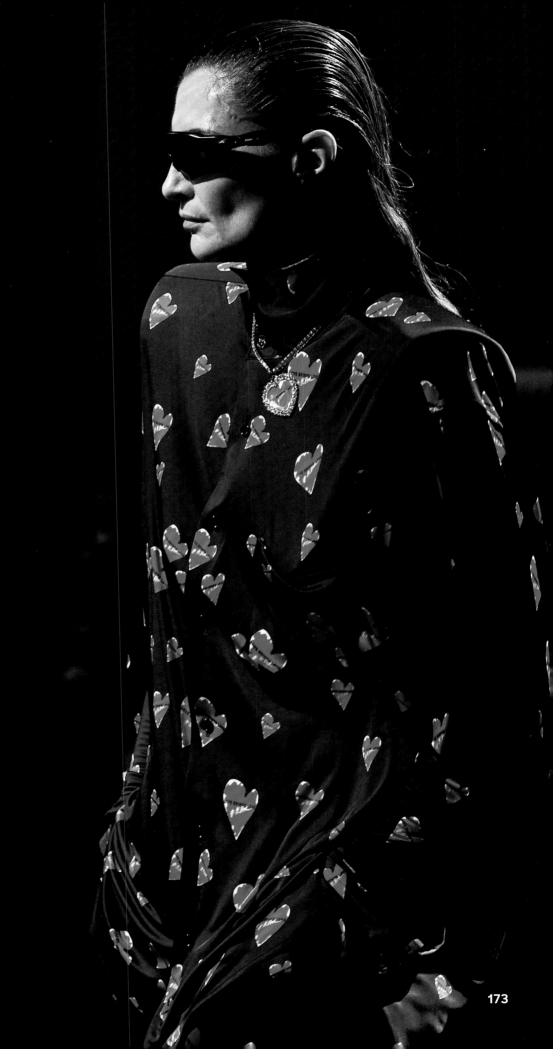

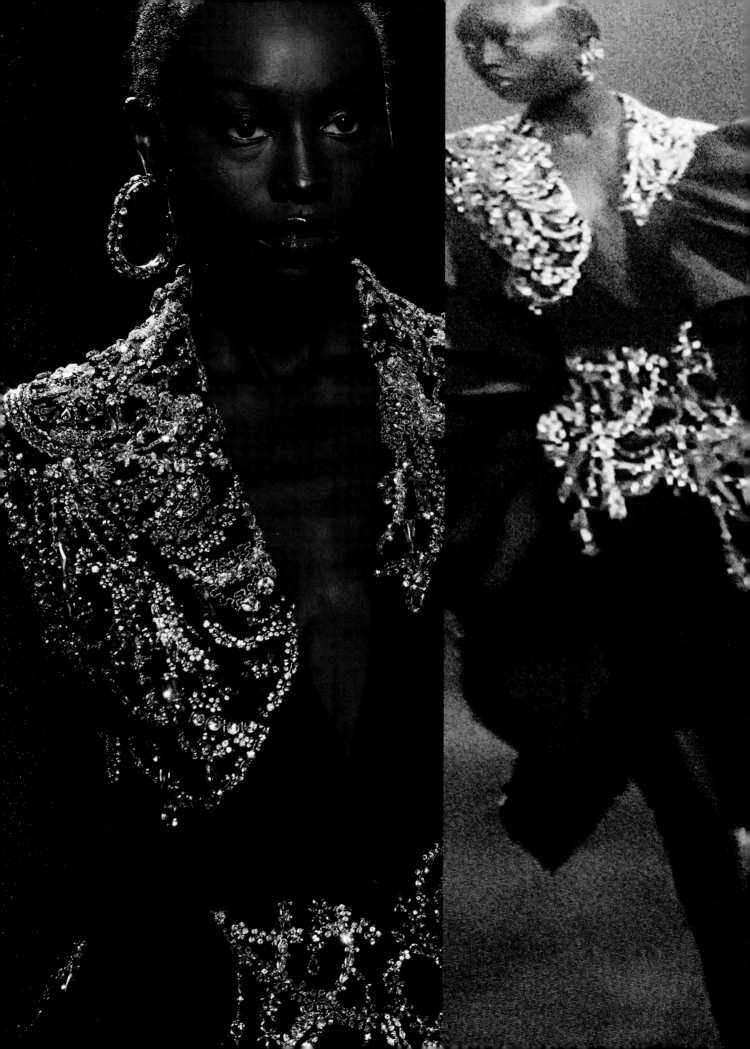

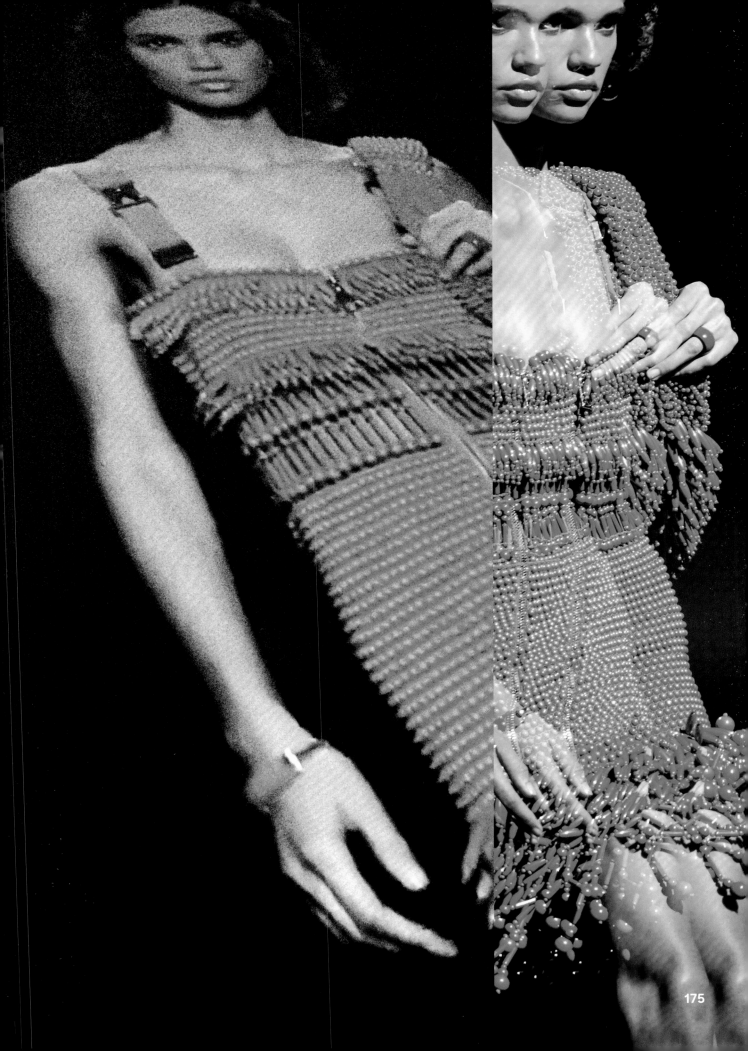

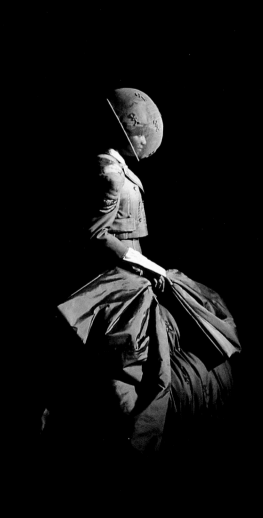

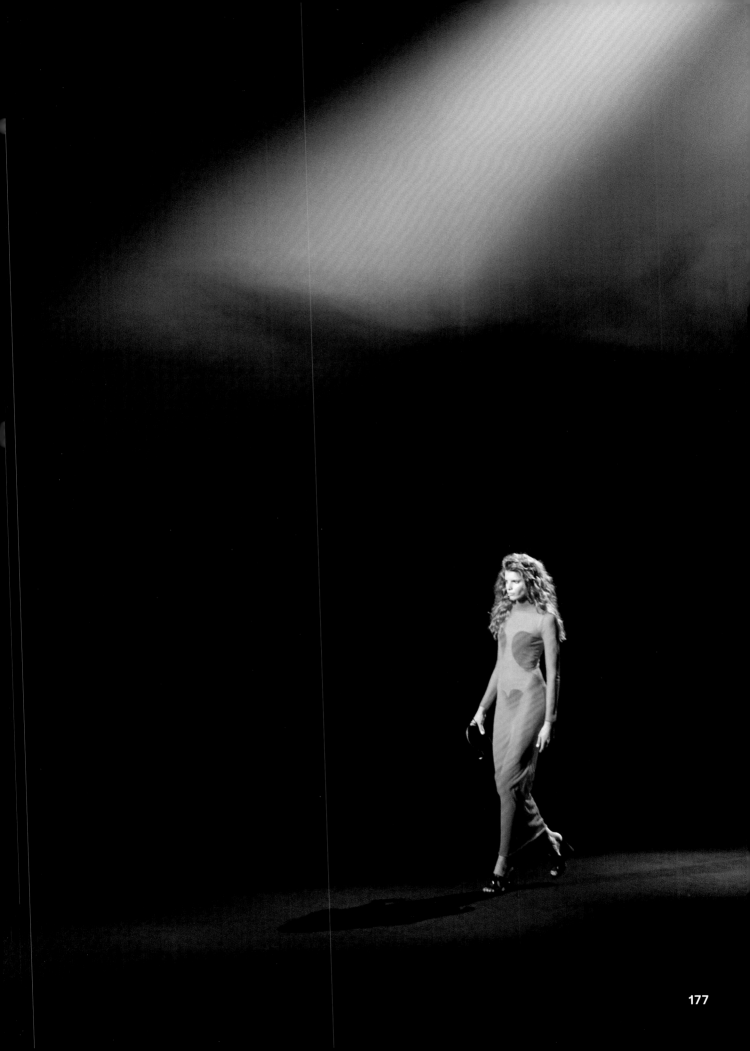

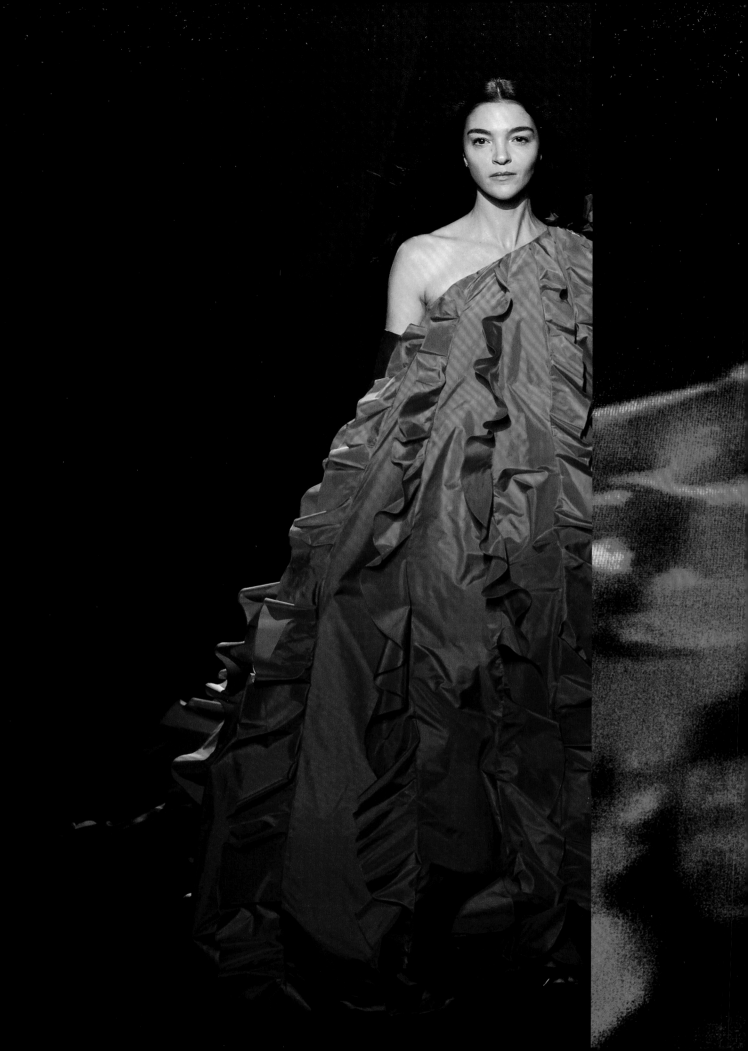

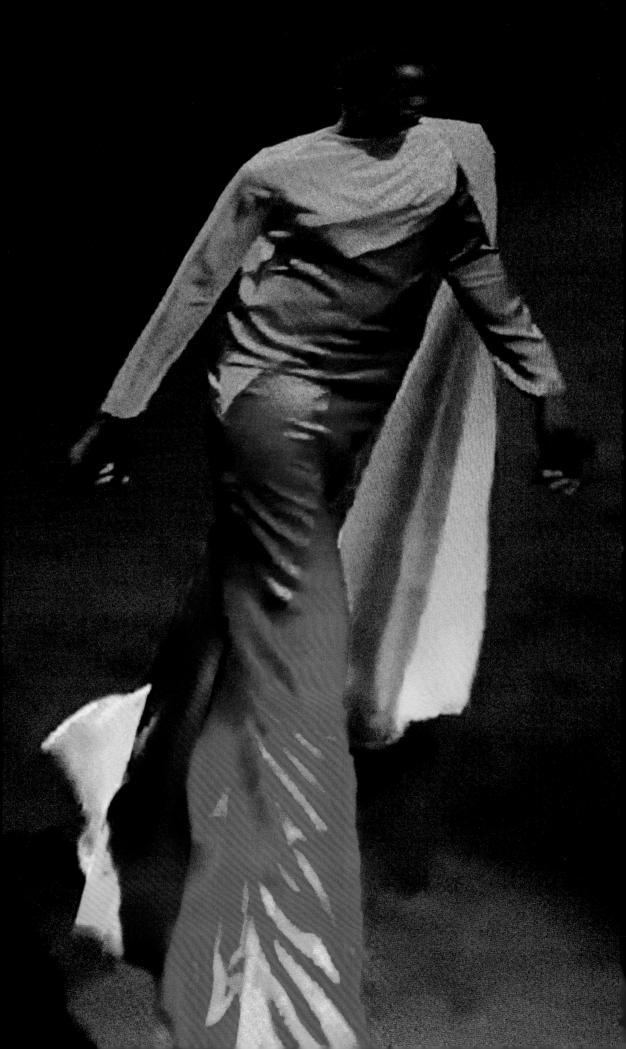

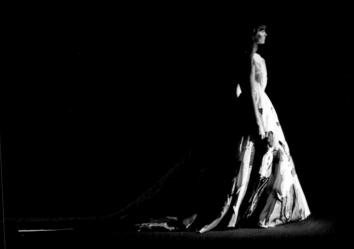

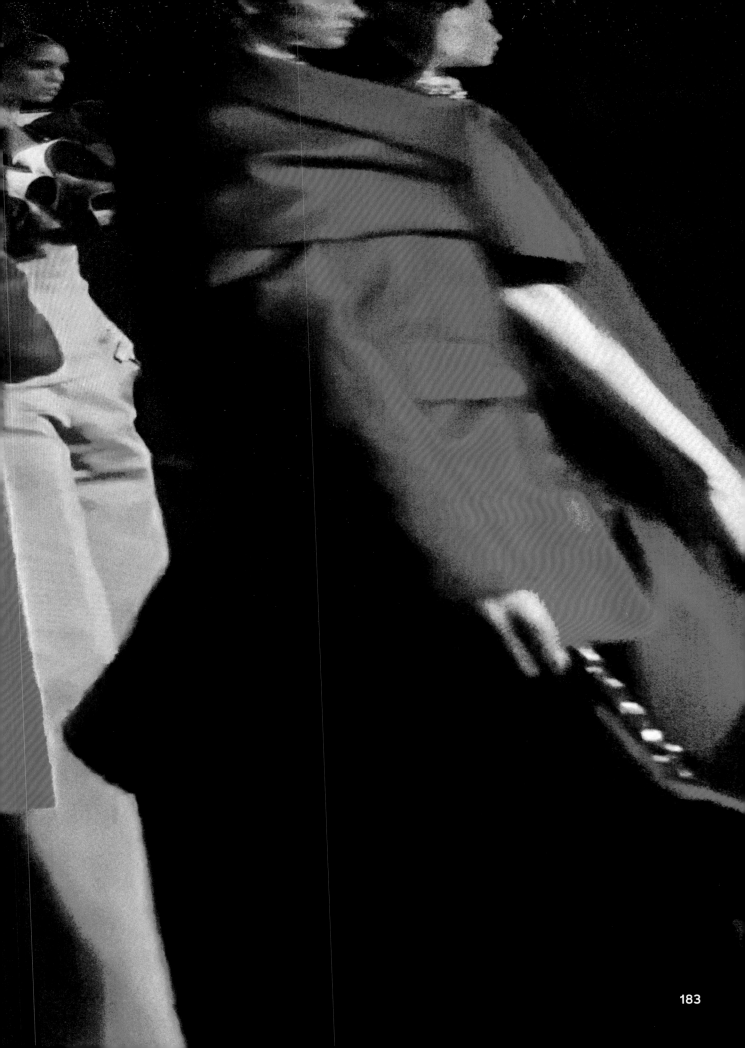

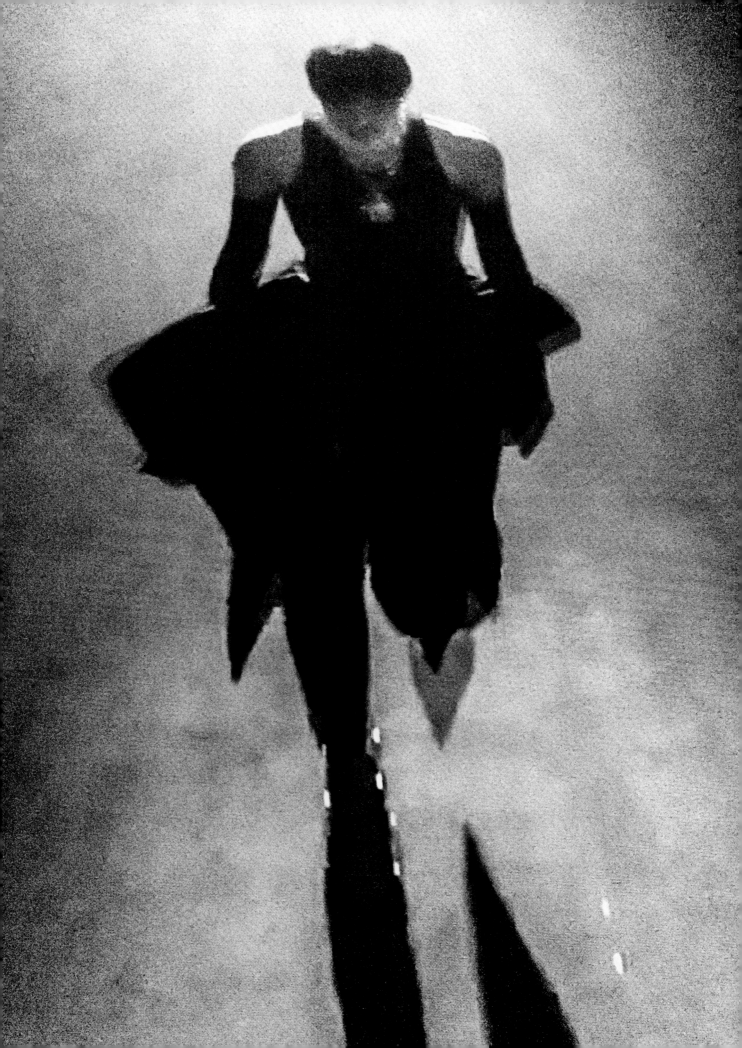

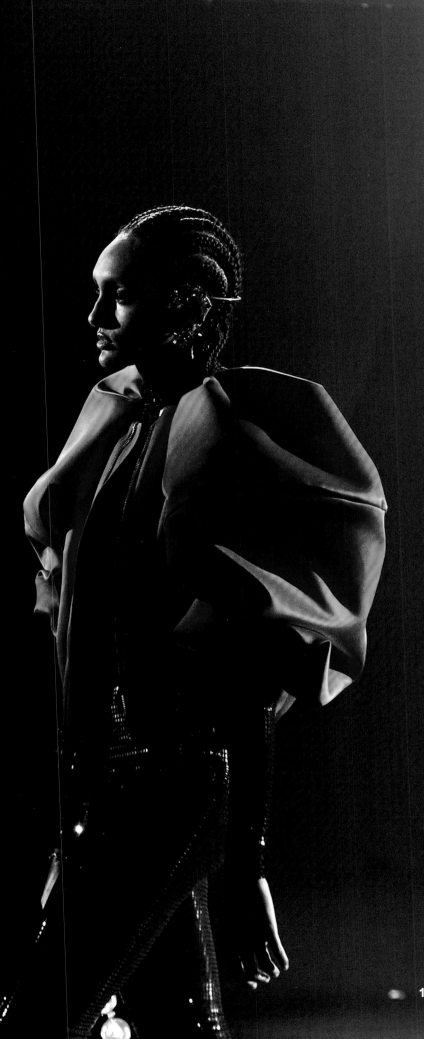

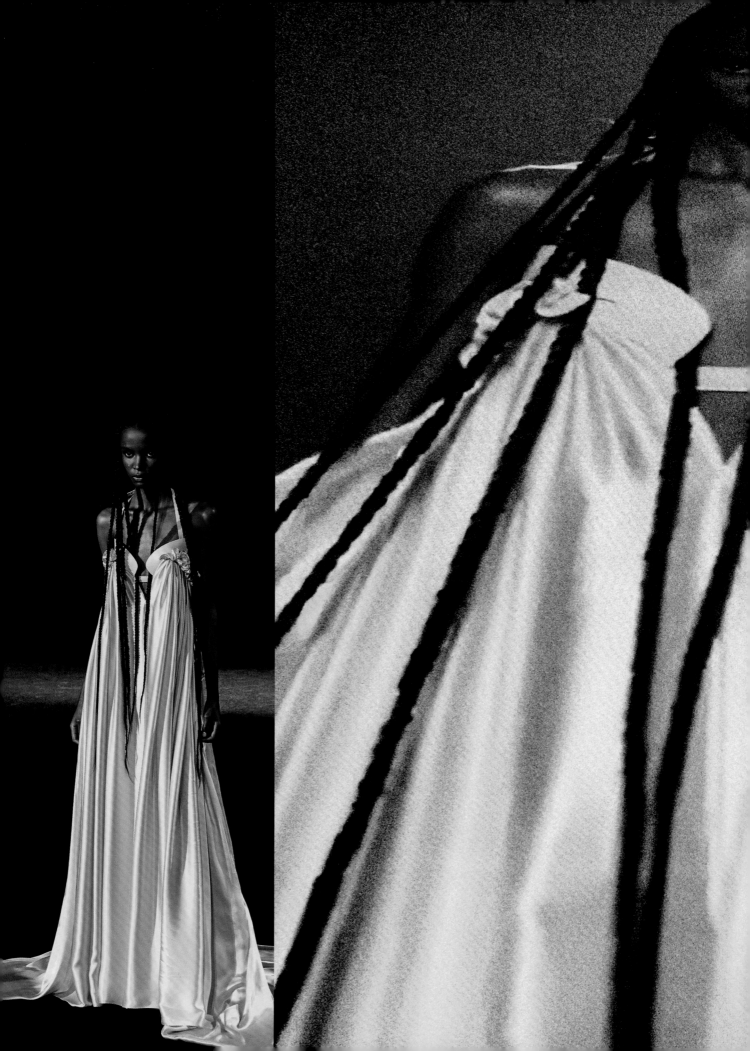

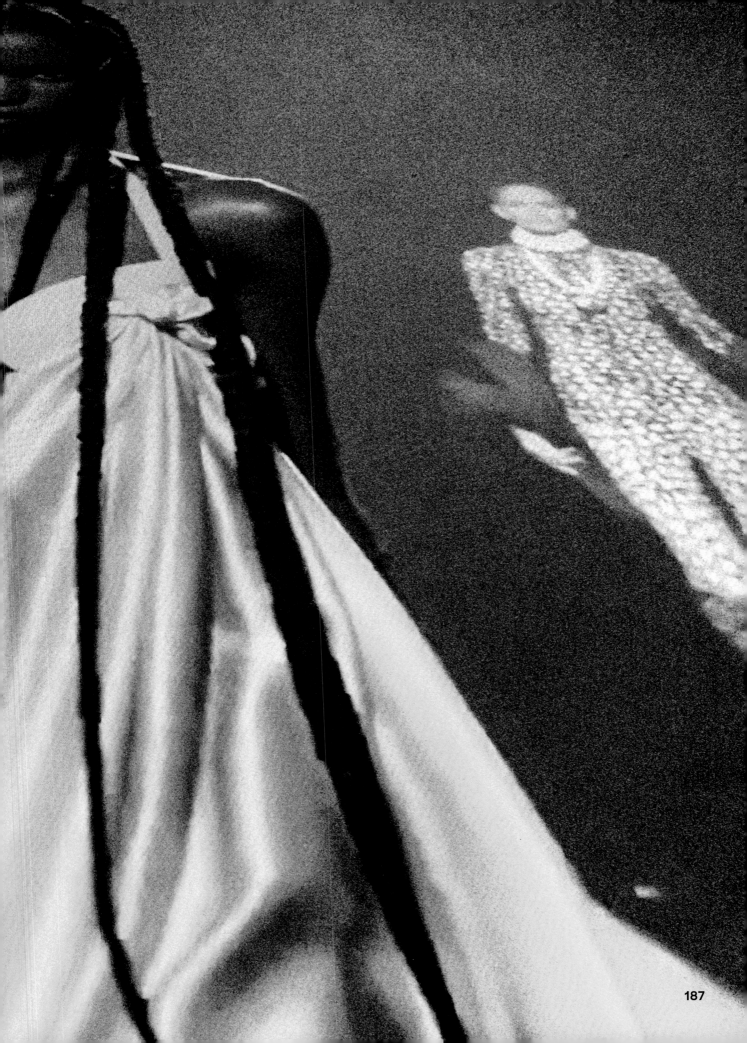

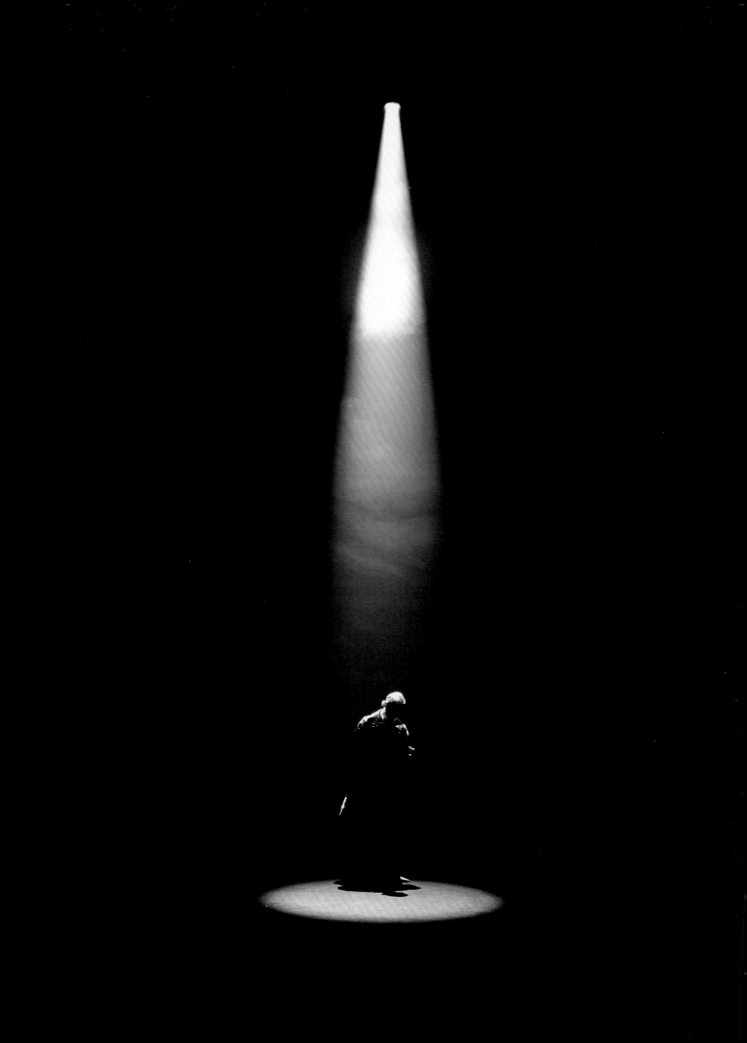

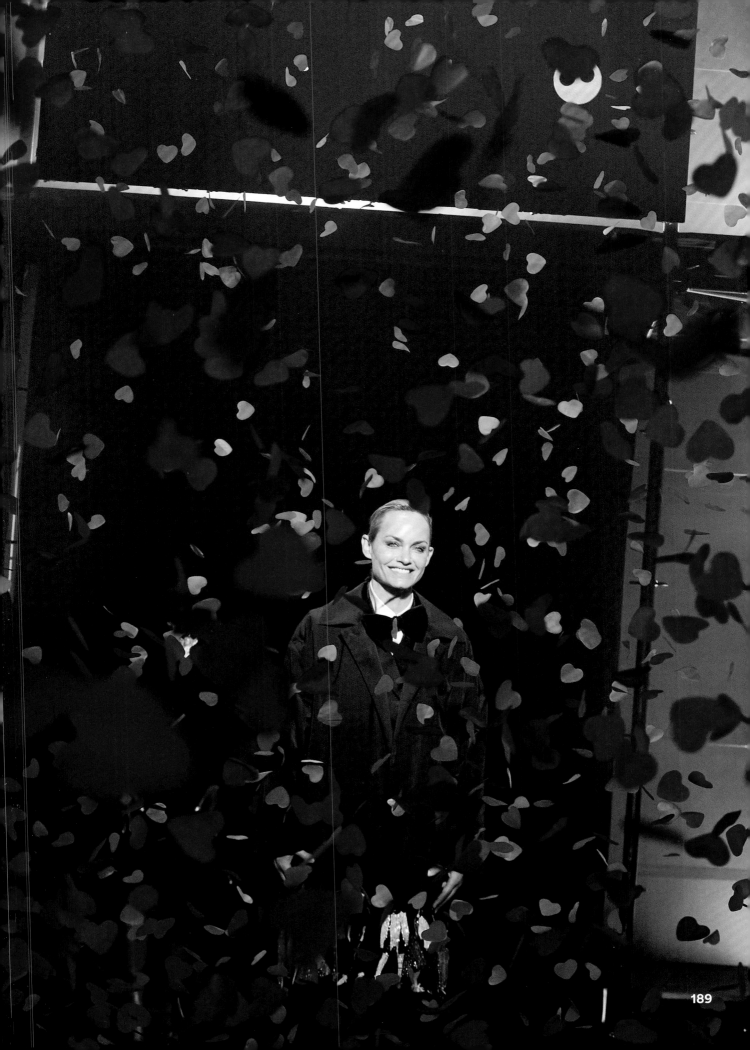

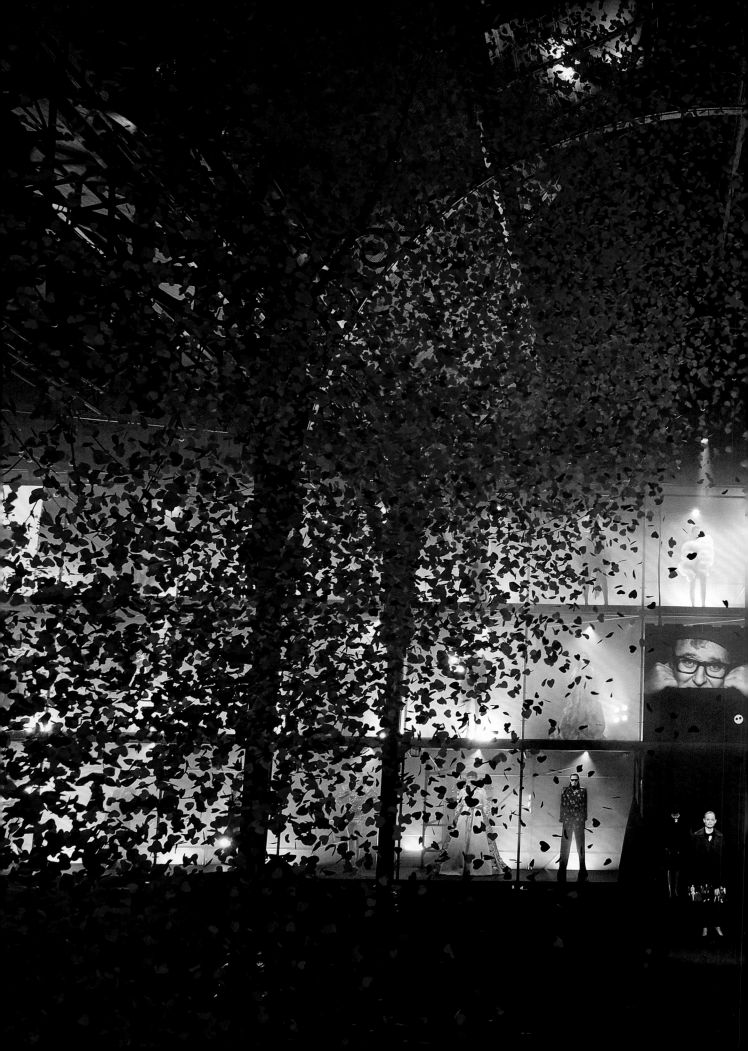

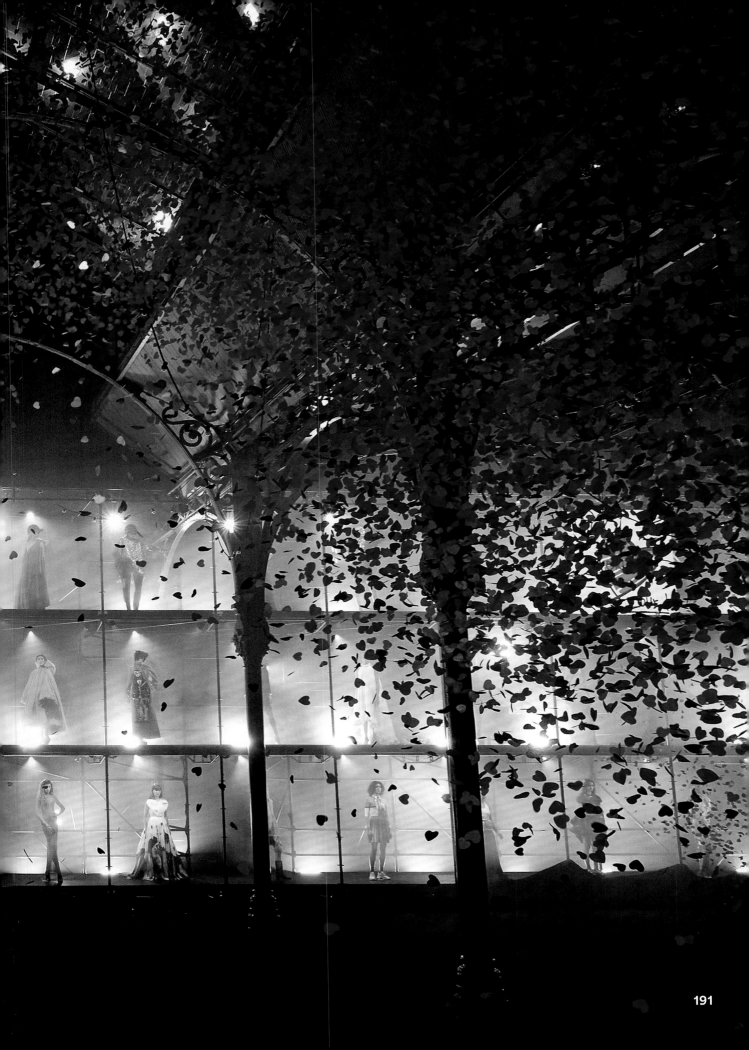

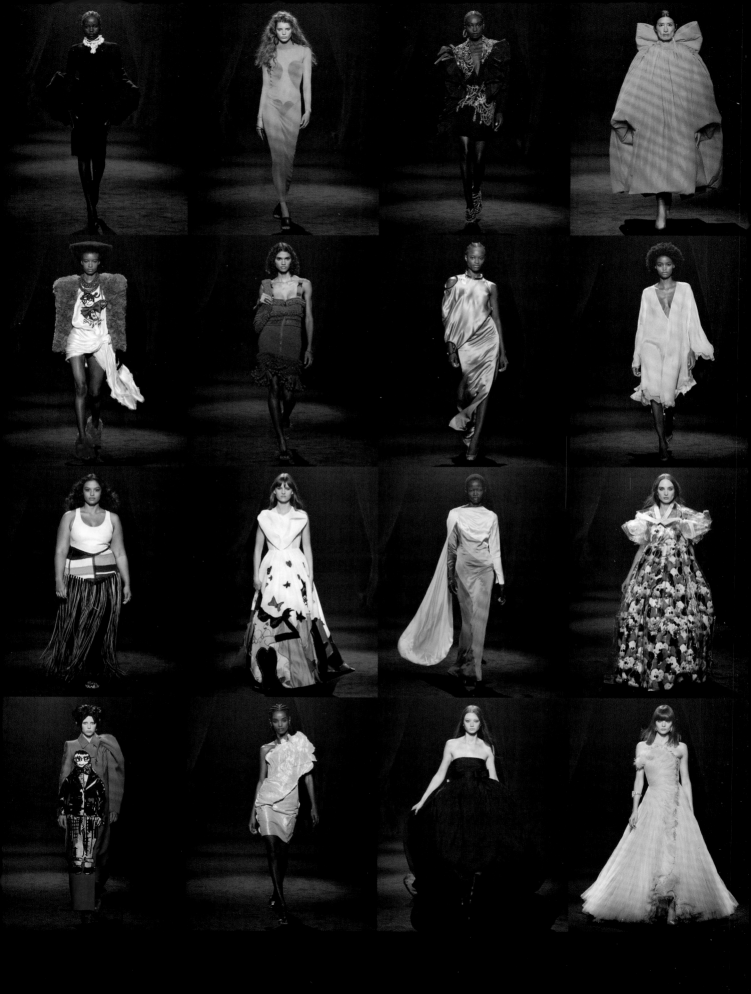

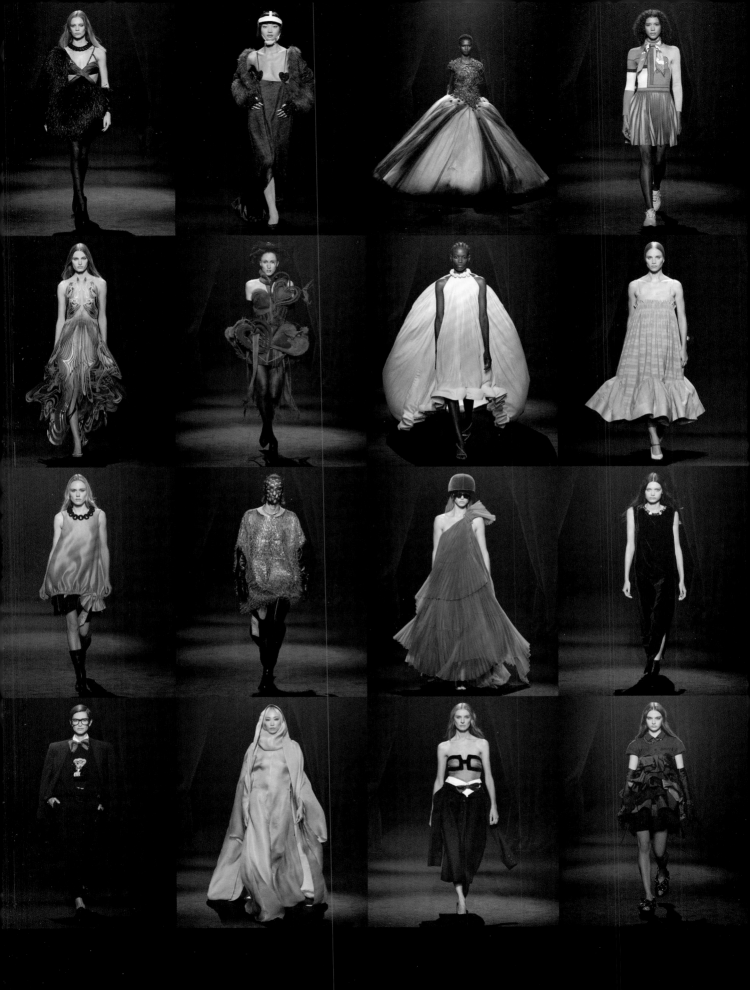

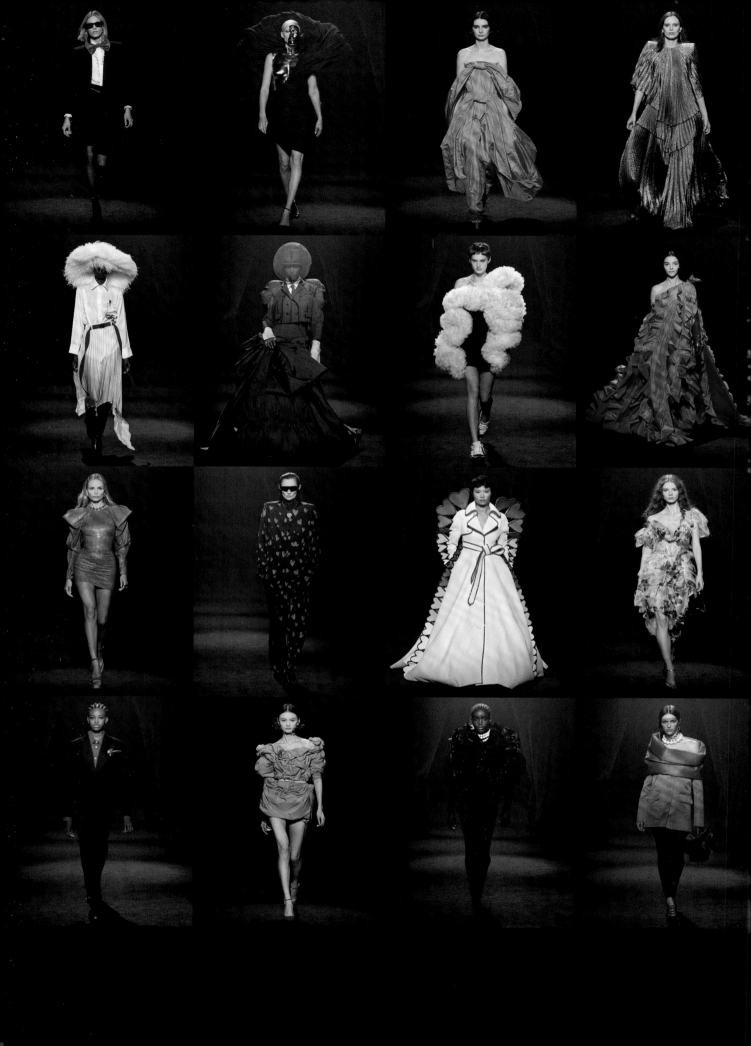

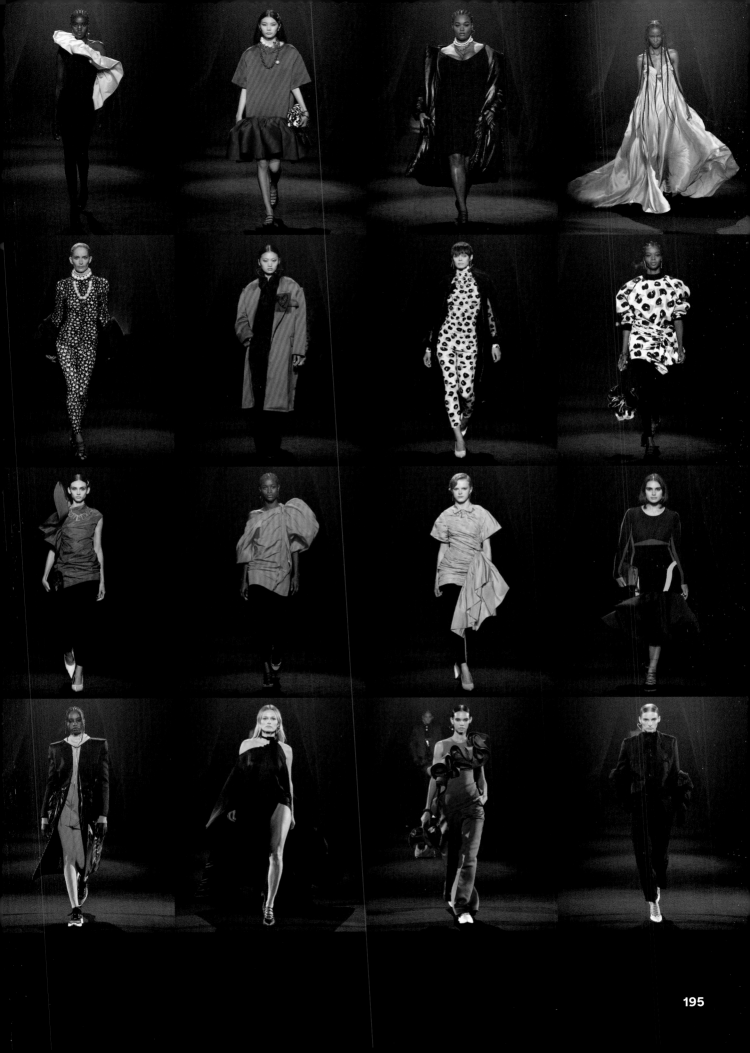

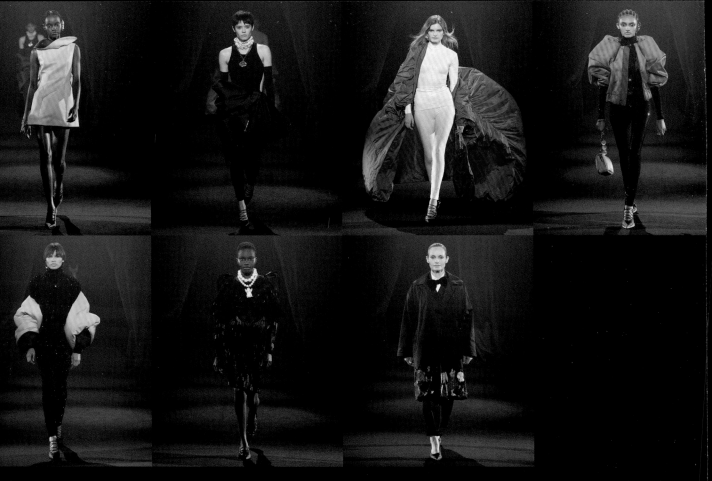

Legend to pages 192 – 196

Page 192 (left to right)

01 ALBER ELBAZ / AZ FACTORY
02 ALAÏA
03 ALEXANDER McQUEEN
04 BALENCIAGA
05 BALMAIN
06 BOTTEGA VENETA
07 BURBERRY
08 CASABLANCA
09 CHLOÈ
10 CHRISTIAN DIOR COUTURE
11 CHRISTOPHER JOHN ROGERS
12 COMME DES GARÇONS
13 DRIES VAN NOTEN
14 FENDI
15 GIAMBATTISTA VALLI
16 GIORGIO ARMANI

Page 193

17 GIVENCHY
18 GUCCI
19 GUO PEI
20 HERMÈS
21 IRIS VAN HERPEN & ADOBE
22 JEAN PAUL GAULTIER
23 LANVIN
24 LOEWE
25 LOUIS VUITTON
26 MAISON MARGEILA
27 OFF-WHITE
28 RAF SIMONS
29 RALPH LAUREN
30 RICK OWENS
31 ROSIE ASSOULIN
32 SACAI

Page 194

33 SAINT LAURENT
34 SCHIAPARELLI
35 SIMONE ROCHA
36 STELLA McCARTNEY
37 THEBE MAGUGU
38 THOM BROWNE
39 TOMO KOIZUMI
40 VALENTINO
41 VERSACE
42 VETEMENTS
43 VIKTOR & ROLF
44 VIVIENNE WESTWOOD
45 WALES BONNER
46 Y/PROJECT
47 – 48 AZ FACTORY

Pages 195 – 196

49 – 71 AZ FACTORY

Legend to pages 145 – 191

145-151: Views from backstage; 153: ALBER ELBAZ / AZ FACTORY; 154-155: BALENCIAGA; 156: LANVIN, LOUIS VUITTON; 157: GUO PEI; 158-159: OFF-WHITE ; 160: ALEXANDER McQUEEN, BALENCIAGA, ALAÏA; 161: RICK OWENS; 162: SCHIAPARELLI; 163: SAINT LAURENT, SCHIAPARELLI; 164: THEBE MAGUGU; 165: LANVIN; 166-167: GUCCI; 168: CHLOÉ; 169: LANVIN, JEAN PAUL GAULTIER; 170: SIMONE ROCHA; 171: VERSACE; 172: GIAMBATTISTA VALLI, DRIES VAN NOTEN, FENDI; 173: VETEMENTS; 174: ALEXANDER McQUEEN; 175: BOTTEGA VENETA; 176: THOM BROWNE; 177: ALAÏA; 178-179: VALENTINO; 180: CHRISTOPHER JOHN ROGERS; 181: CHRISTIAN DIOR COUTURE; 182-189: ALBER ELBAZ / AZ FACTORY; 190-191: Finale

Dearest Alber,

You took a chance on us, bringing us together to create your dream factory. You showed us how to follow our hearts. You dazzled us with your intuitive genius. You urged us to think of solutions first, to push the boundaries, to make the impossible possible.

You taught us that no dream is too big and no detail is too small. We will never forget to stay determined, to create with intent, and to impose meaning and purpose on everything that we do. We will honor your promise of love, trust, and respect.

We will treasure our memories of you, your kindness, your laughter, your emotions, your contradictions, your limitless creativity. We will forever cherish your stories, your generosity, your humble spirit, your love, and your joy.

We miss you, we will love you always.

AZ Factory

THANK YOU

In loving memory of Virgil Abloh, a rare creative soul who left us far too soon.

We would like to offer our special thanks to the following people, without whom we would not have been able to realize the *Love Brings Love* show.

Thank you, thank you, thank you.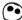

Participating designers and their teams

Johann Rupert, Jérôme Lambert,
Philippe Fortunato, Anne Dellière,
and the Richemont Group

Ralph Toledano, Pascal Morand,
and the Fédération de la Haute
Couture et de la Mode

Babeth Djian
Hania Destelle
Katy Reiss
Ariel Wizman & Didier Léglise

Etienne Russo and the Villa Eugénie team
Lucien Pagès and the team
Piergiorgio Del Moro and the team
Pat McGrath and the team
Guido Palau and the team

Models and their agencies
Photographers and video team

And all those who have contributed
so generously in every shape and form.

Thank you

Cover Alber Elbaz, 2011.
Photo by Jan Welters, Trunk Archive.

p. 4 Alber Elbaz, 2019.
Photo by Alex Koo.

p. 28 Geoffrey Beene with Alber Elbaz, 1989.
Photographer unknown, Alber private collection.

p. 40 Alber Elbaz for Lanvin,
Autumn / Winter 2010.
Photo by But Sou Lai.

p. 50 Alber Elbaz, 2011.
Photo by Jan Welters, Trunk Archive.

p. 58 Alber Elbaz for Guy Laroche, 1998.
Photo by Thierry Orban, Getty Images.

p. 68 Lanvin by Alber Elbaz,
Spring / Summer 2008.
Photo by But Sou Lai.

p. 76 Alber Elbaz, 2021.
Courtnesy of AZ Factory.

p. 79 Yves Saint Laurent and Alber Elbaz, 1999.
Photo by Ferton, Gamma Rapho.

p. 85 Alber Elbaz, 2007.
Photo by Sarah Moon.

p. 96 Karlie Kloss for Lanvin by Alber Elbaz,
Spring / Summer 2012.
Photo by But Sou Lai.

p. 117 Alber Elbaz for Lanvin,
Spring / Summer 2008, 2007.
Photo by Michel Dufour, Getty Images.

p. 118 Alber Elbaz for Lanvin
Fall / Winter 2008, 2008.
Photo by Victor Virgile, Getty Images.

p. 135 Alber Elbaz for AZ Factory, 2020.
Photo by Stéphane Gallois.

p. 142 – 143 Alber Elbaz, 2009.
Photo by But Sou Lai.

Alcibiade Cohen
p. 44, 98, 145 (3 & 4), 147 (2 & 6),
149 (3, 4, 5), 151 (5 & 6)

Andrea Adriani
p. 152, 154, 157, 159, 163, 164, 167, 168, 169, 173, 175 (right), 176, 177, 178, 185, 188, 189, 191

Anthony Ghnassia / Getty Images for AZ Factory
Endpaper (front & back), p. 156, 160, 162, 171, 181

Armando Grillo
p. 174 (left)

But Sou Lai
p. 100, 155, 158, 165, 170, 174 (right), 175 (left), 179, 180, 183, 184, 187

Casper Kofi, for Viktor & Rolf
p. 126

Filippo Fior
p. 153, 166, 192, 193, 194, 195, 196

Katy Reiss
p. 145 (2), 147 (1, 4, 5, 7, 9), 149 (2 & 8), 151 (2 & 7)

Léon Prost
p. 149 (9), 172

Maxime Imbert
p. 149 (1), 151 (3 & 9)

Oriane Verstraeten
p. 145 (1), 147 (3 & 8), 149 (7), 151 (1)

Romain Fior
p. 147 (10), 149 (6), 151 (4 & 8)

Timothee Chambovet
p. 161

Models
Abby Champion, Achan Biong, Achenrin Madit, Adele Aldighieri, Adit Priscilla, Adut Akech, Alyda Grace, Amber Velletta, Amar Akway, Anja Rubik, Anna Cleveland, Anyiel Majok, Angair Biong, Aylah Peterson, Barbara Valente, Beyoncé Ambrose, Blesnya Minher, Cara Taylor, Christie Munezero, Claire Delozier, Devyn Garcia, Dilone, Edie Campbell, Edita Vilkeviciute, Felice Nova Noordhoff, Georgina Grenville, Greta Hofer, Hannah Motter, He Cong, J'adore Benjamin, Jennifer Girukwishaka, Jill Kortleve, Jordan Daniels, Karen Elson, Karina Krawczyk, Kayako Higuchi, Kiki Willems, Krini Hernandez, Kyla Ramsey, Lexi Boling, Lina Cruz, Louise De Chevigny, Louise Robert, Maggie Maurer, Maike Inga, Malika Louback, Mao Xiaoxing, Marine Van Outryve, Mariacarla Boscono, Maty Fall, Mayowa Nicholas, Meadow Walker, Mirthe Dijk, Mylene Herani, Natasha Poly, Nyagua Ruea, Olga Sherer, Oumie Jammeh, Precious Lee, Rebecca Leigh Longendyke, Sacha Quenby, Sade can der Hoeven, Saibatou Toure, Sara Grace Wallerstedt, Sherry Shi, Signe Veiteberg, Soo Joo Park, Suzi De Givenchy, Thomas Riguelle, Vira Boshkova, Yilan Hua.

love brings love

L'amour porte l'amour

l'amore porta l'amore

Liebe bringt Liebe

LIEBE BRINGT LIEBE

L'AMOUR AMÈNE L'AMOUR

L'AMOUR APPORTE L'AMOUR

Liefde brengt Liefde

LIEFDE BRENGT

Dragoste

amour trae amor

LOVE BRINGS LOVE

愛は愛を呼ぶ

愛生愛